Sean Smith's laptop during his embed with
US Marines, Al Anbar province, Iraq, 2007

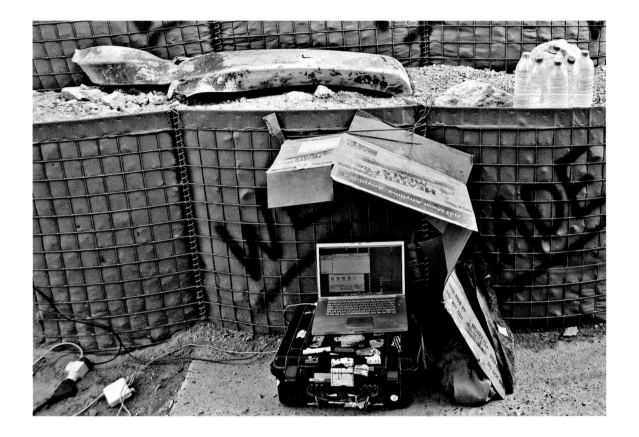

FRONTLINES

CONFLICT IN THE 21st CENTURY

SEAN SMITH

Introduction by Jon Snow

gb
guardianbooks

For Natalie, Amber and Holly

US Marines capture suspected Sunni
insurgents, Al Anbar province, Iraq, 2005

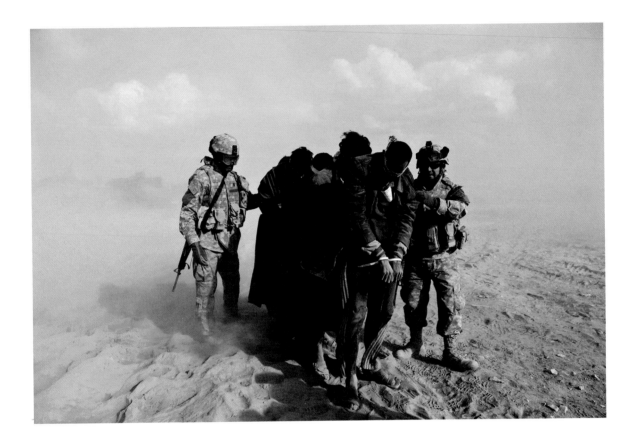

War is not merely a political act, but also a political instrument,
a continuation of political relations, a carrying out of the same by other means.

Carl Philipp Gottlieb von Clausewitz

CONTENTS

INTRODUCTION
by Jon Snow

Sean Smith has lived an extraordinary decade of war. A decade without a world war, and yet one marked by the scale and sheer nastiness of ruinous civil and regional conflict. His images capture both the beauty and the beastliness of war. Contrast, for example, the gorgeous landscape of eastern Congo with the conflict in which tens of thousands of people have died every month.

Inevitably, perhaps, his photo-journalistic journey is dominated by Iraq, just as so much of our engagement with war in present times is shaped by that vast adventure. Iraq is a war that has signalled the limits of power to the old order. So much so that when it came to the revolutions across northern Africa in 2011, the Western powers, who in the nineties had managed war in Kosovo without the stamp of a UN resolution, found that their options in Libya required greater UN acceptance than they had ever secured for Iraq.

War is often a big landscape, but it is intimate too. The opening photos of the Israel/Palestine conflict reveal what so many of us forget. Despite the rockets and bombs launched by both sides, images reveal that fighting at close quarters has been very uneven – teenage Palestinian youths casting rocks by hand or with slings against heavily armed Israeli soldiers firing live rounds.

In laying out a decade of war, Smith portrays the awful underlying truth of the endlessness of the Middle East conflict – a wounded man on a stretcher, a woman with a white flag signalling peace on a devastated dusty street. In fewer than twenty shots we see pride, destruction, death and defiance, humiliation, grief and surrender. Those ingredients remain, despite the relative absence of what outsiders would regard as war itself.

Sean Smith's Afghanistan opens with a panoramic sweep of Kabul's graveyard juxtaposed with the beauty and character of the Afghan people. The shockingly close portraits of heroin addicts establish the backdrop of opium riches and exploitation that have informed war here for centuries.

The wedding scene in Baghdad shows Iraq's residual development, despite war's effort to take it back to the Middle Ages. Sudden splashes of red – in a dress, in a jockey's shirt, in ceremonial officers' tunics – suggest that war may have been put to rest. Victory poses suggest an early belief that war with Iraq might prove an easy option.

It wasn't. The terrible clean-up of bodies speaks of a carnage so great that the dead lost all identity, all individuality: they were mere inanimate corpses.

The prosecutors of the Iraq war seem, at times, little removed from the scenes they have created. Far from home, cut off from civilian humanity, they are shown baring the grim reality of long tours of duty on a never defined frontline.

In Smith's Iraq it is impossible to escape the indignity and smoky pointlessness of the conflict: a corpse here, bled dry from a wound in the head; a group of grieving women or herded populaces there – all in the name of liberation from a tyrant we, or our forbears, helped create.

Lebanon's utter destruction in the middle of the decade shows the overwhelming impact of Israeli military might, and a confidence that such a course of action was in some way right. Like the war in Iraq, Lebanon's agony was something I experienced at first hand. These images trip memories we who witnessed them try to erase. Memories of events we felt powerless to influence – empowered only to note and report them. The stunned, bloody grief enshrined in the image of the

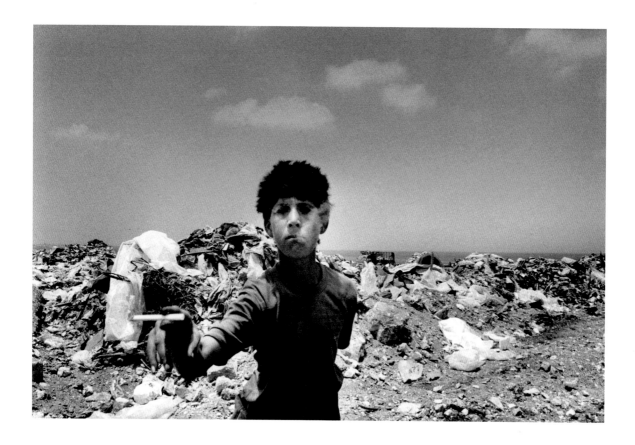

shirtless child standing amid his weeping, devastated family speaks many thousands of words.

In Congo, darkness and death stalk a beautiful, verdant, colourful land in which one of the greatest atrocities known to mankind continues to unfold. If they had been white people with laptops, would we have done more? This is Africa's first world war – a war in which as many as nine African nations have sought war, peace and spoils. The outside world has barely noticed. Yet in 2010 the death toll was at times running to a staggering 45,000 a month. Diamonds and death, it seems, are forever. The battle for resources has deteriorated to a battle to outdo your enemy's sub-humanity.

This book, painful though so much of it is, is an account of a decade of global failure in the face of local and regional wars, of which we knew little and cared less. We dipped into our pockets when reminded to, but we did not do much to find ways of ending them. In each of these conflict arenas Sean Smith's powerful work reminds us that these are snapshots of wars that in Afghanistan and Iraq have raged most of the decade and in other zones for very much longer. We need to absorb their message, we need to inform ourselves, and we must allow that information to generate change.

Boy scavenging from rubbish tip near the Green Line, Beirut, Lebanon, 1997

In September 1993, Israel and the Palestinian Liberation Organisation (PLO) agreed to mutual recognition under the terms of the Oslo declaration. The following year, Yasser Arafat returned from exile and the Palestinian Authority assumed responsibility for the administration of some parts of Gaza and the West Bank, including major towns, but Israel retained control of large areas of the occupied territories, including East Jerusalem, and continued to expand Jewish settlement.

In July 2000, Bill Clinton's attempt to broker a final agreement between Arafat and the Israeli prime minister, Ehud Barak, ended in failure. A highly contentious visit by Ariel Sharon to the Temple Mount complex in Jerusalem further inflamed Palestinian anger over the failure of talks and prompted the start of the second intifada, with street demonstrations rapidly turning violent.

In 2002, Israel responded to a wave of suicide bombings by sending tanks and troops to reoccupy Palestinian towns in the West Bank. Much of Arafat's compound in Ramallah was reduced to rubble and the movement of Palestinians throughout the occupied territories was greatly inhibited by numerous Israeli checkpoints. Violence escalated.

The US published its 'road map' to peace in April 2003, but the process quickly stalled after the Israeli government demanded there be an absolute end to Palestinian violence before it would fulfil the requirement to halt military incursions into the occupied territories and freeze construction of Jewish settlements.

Throughout 2004 the violence continued, and Israel launched major military assaults in Gaza and the West Bank. In November, Arafat died and was succeeded by Mahmoud Abbas. A precarious ceasefire was announced the following year.

Funeral of bomb-maker Abu Ayash, assassinated by Israeli army, Ramallah, 1996

Yasser Arafat, Jericho, 1996

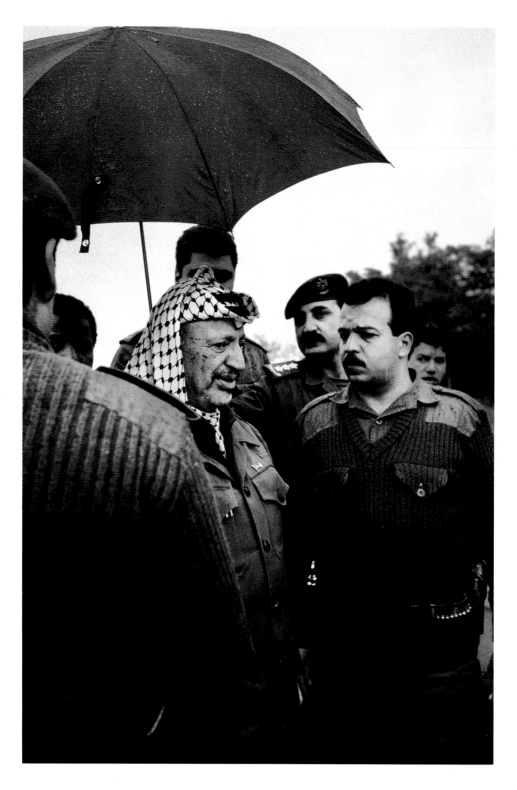

Armed members of Yasser Arafat's Fatah militia during the funeral procession of Muayyad Osama Jawarish who had been shot the previous day during clashes with Israeli soldiers, Bethlehem, 2000

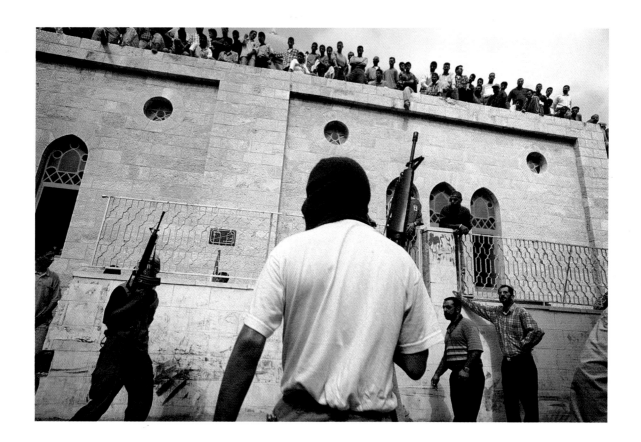

Palestinian youths clash with
Israeli forces, Bethlehem, 2000

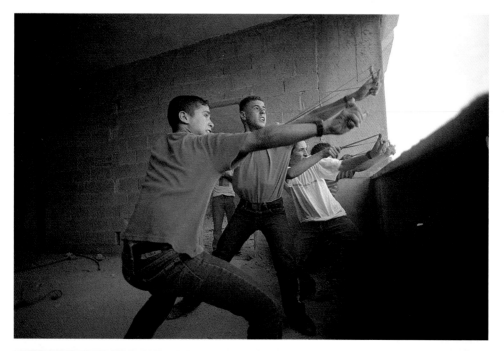

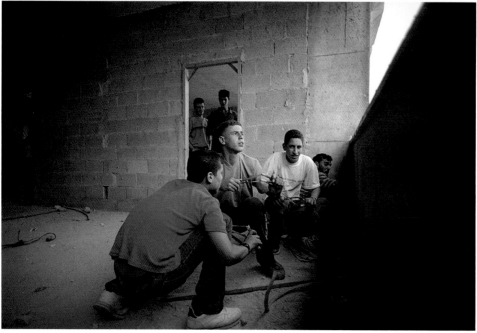

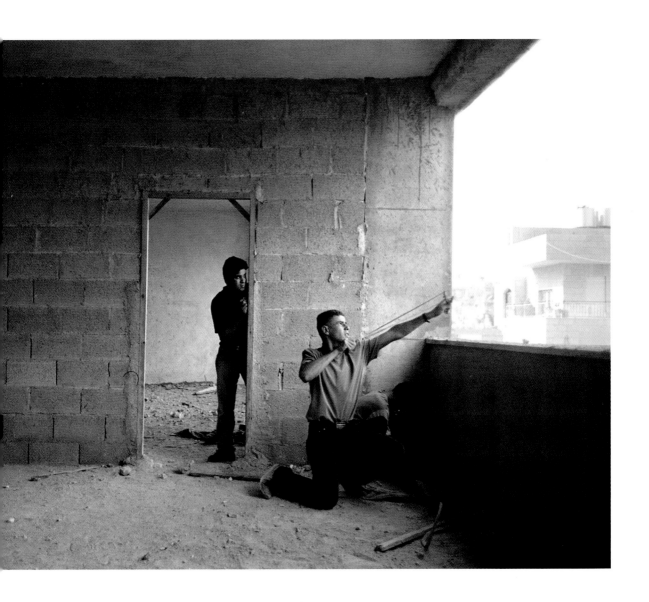

FRONTLINES | ISRAEL

Palestinians clash with Israeli soldiers,
Ramallah, 2000

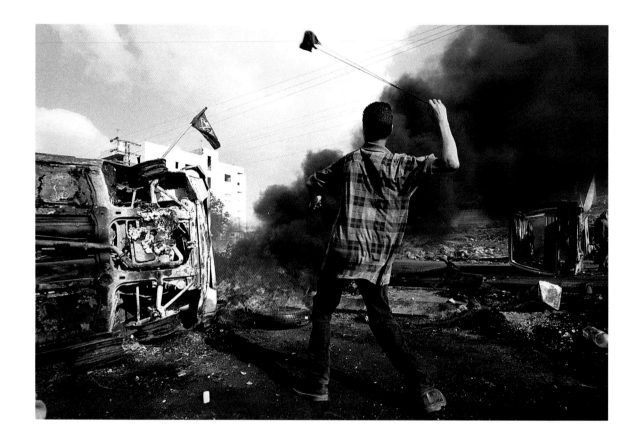

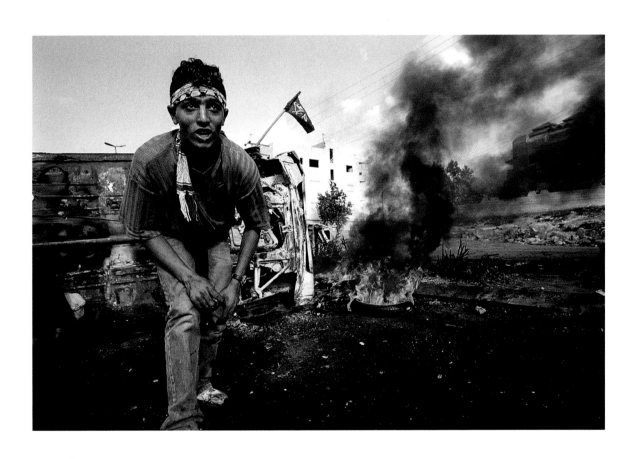

Palestinian youths clash with Israeli forces,
Rachel's Tomb, Bethlehem, 2000

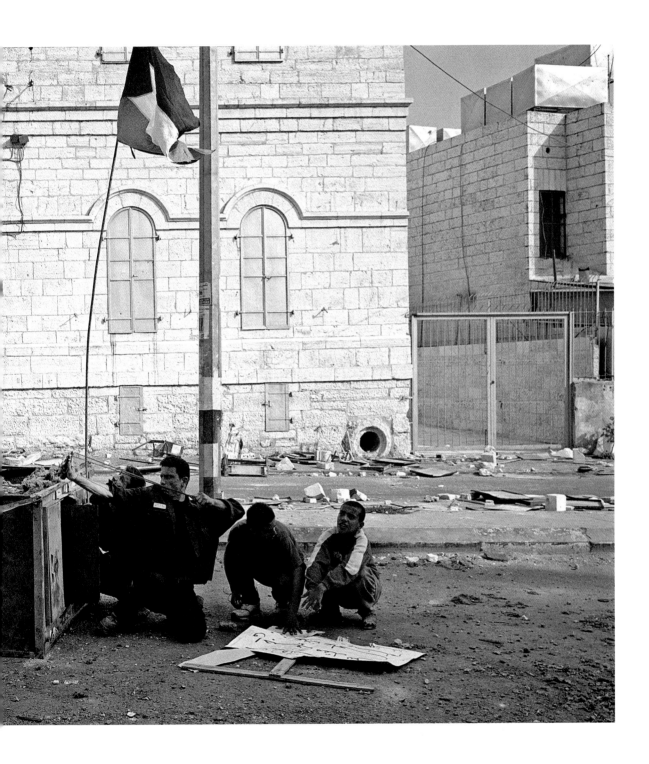

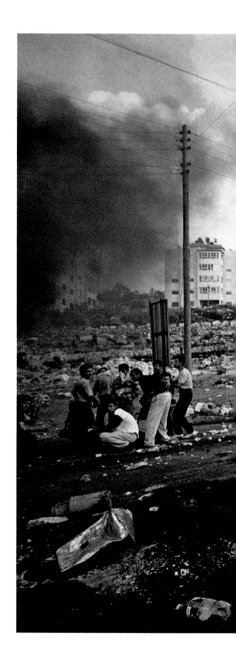

Palestinian demonstrators throw rocks at Israeli
forces during ongoing clashes, Ramallah, 2000

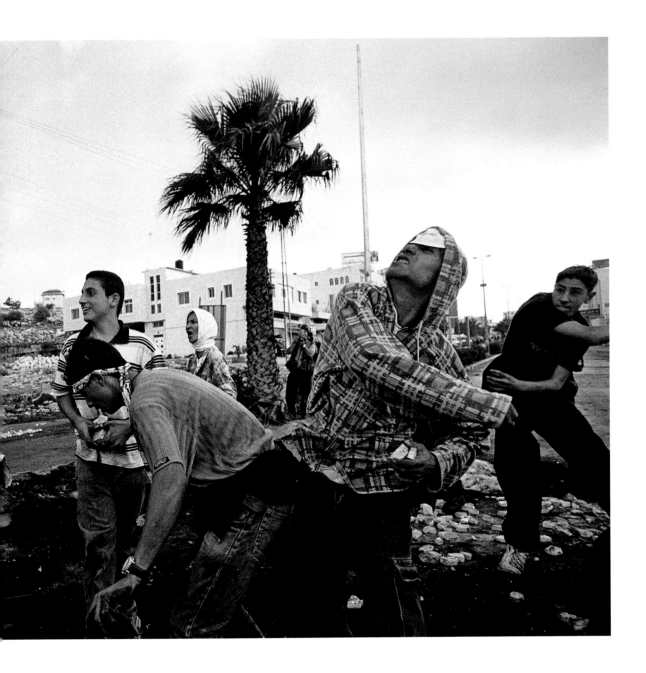

Medical relief volunteers carry an injured man from the emergency hospital in
the Al Beak mosque to the Anglican Hospital during the curfew, Nablus, 2002

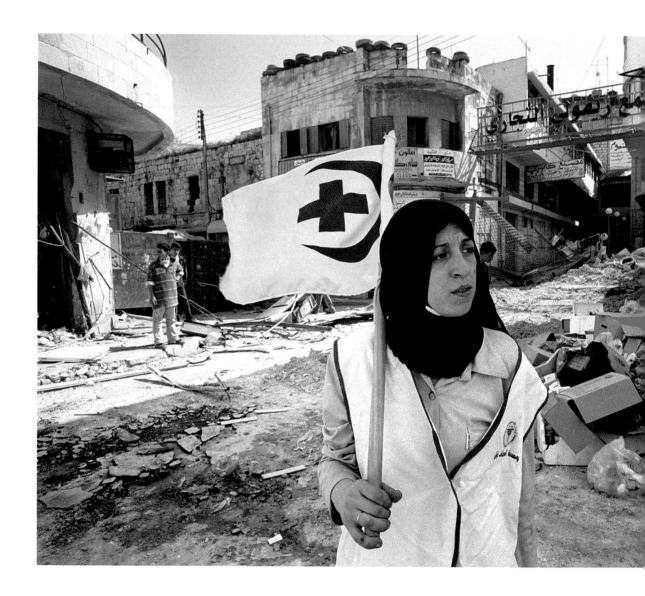

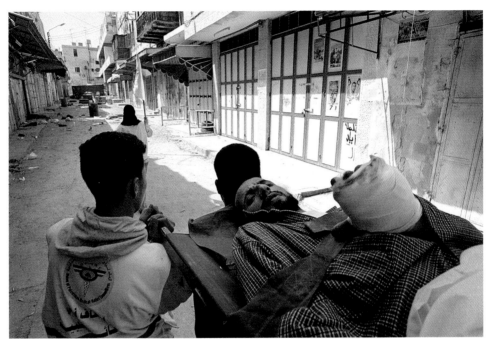

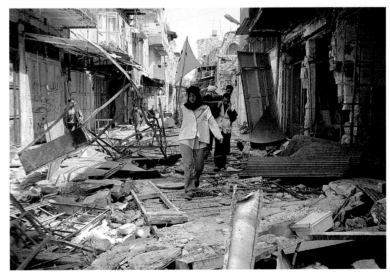

Qalandia checkpoint, outside Jerusalem
on the road to Ramallah, 2004

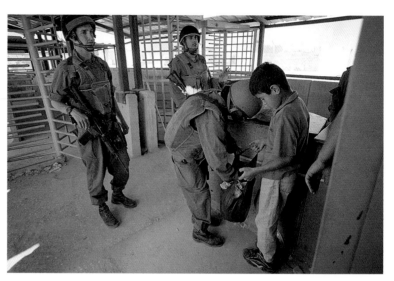

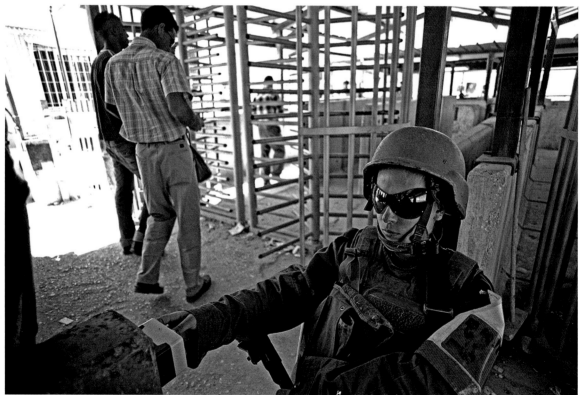

Palestinians show their identity papers on the way to Friday prayers. Only those over 45 are admitted. The Dome of the Rock, Jerusalem, 2004

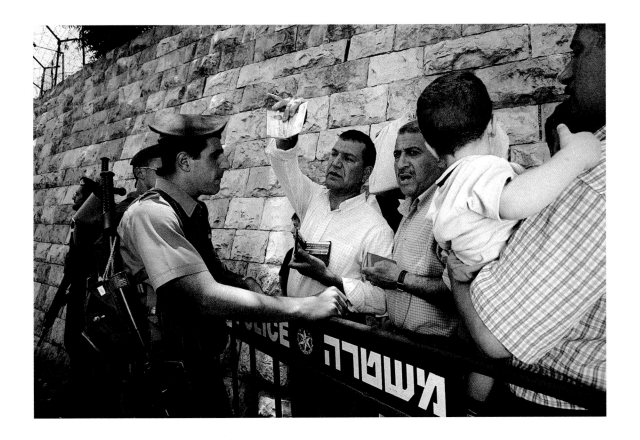

Red Crescent Ambulance workers taking
injured to Rafidia hospital, Nablus, 2002

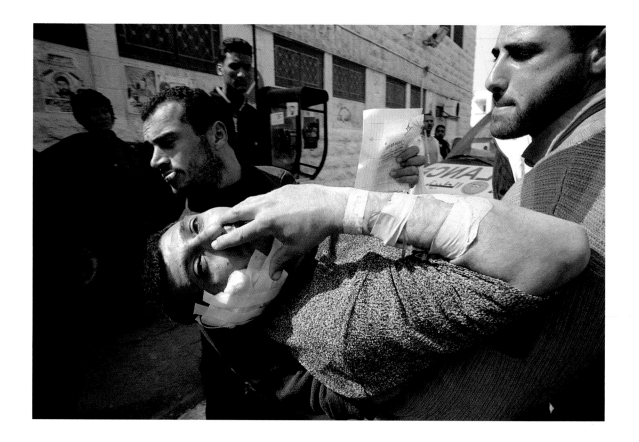

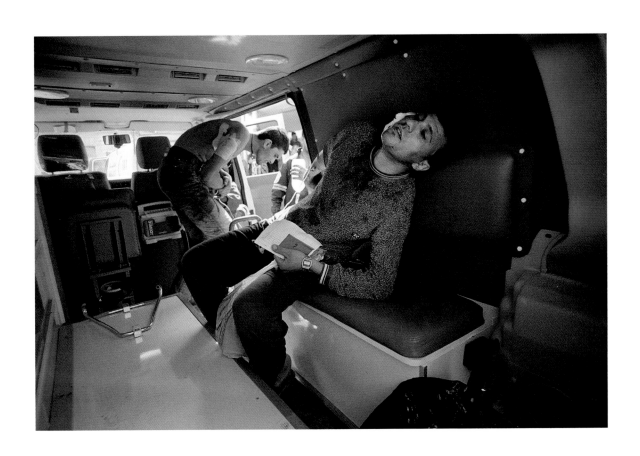

Israeli security barrier near Qalandia checkpoint,
between Jerusalem and Ramallah, 2004

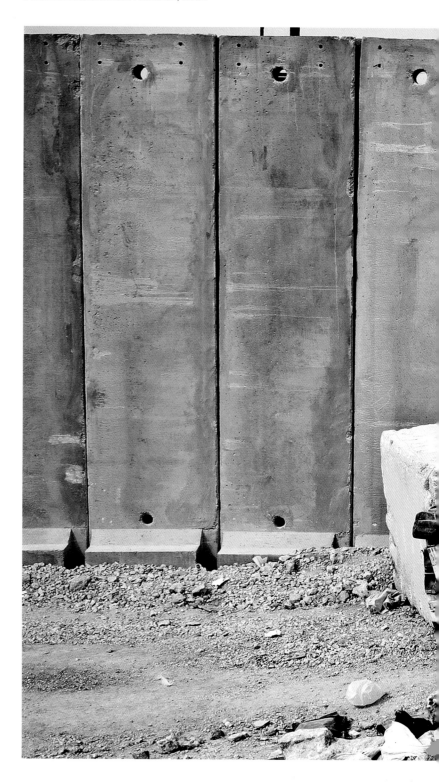

FRONTLINES | ISRAEL

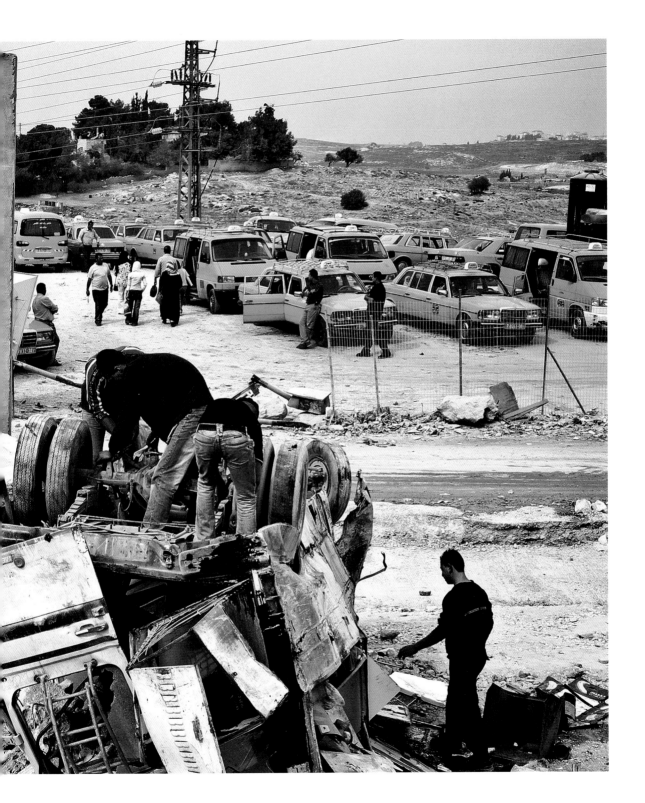

FRONTLINES | ISRAEL

The initial optimism following the invasion of Afghanistan in October 2001, known as Operation Enduring Freedom, and the removal of the Taliban from power was short-lived. Efforts to promote stability, establish a transitional administration and distribute aid had limited effectiveness. As unemployment levels remained high, disillusionment – particularly among young, educated Afghans – became widespread.

In early 2003, the US defense secretary Donald Rumsfeld declared that most of Afghanistan was secure. However, by the summer of 2006 the Taliban had regrouped and insurgency was widespread. This included numerous attacks on non-governmental aid workers and civilians. Violence was particularly intense in Helmand and Kandahar provinces, which had long been seen as Taliban strongholds.

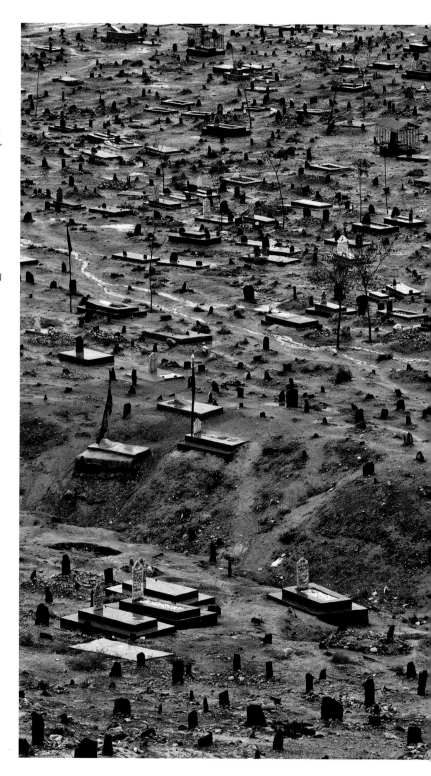

Graveyard, Kabul, 2006

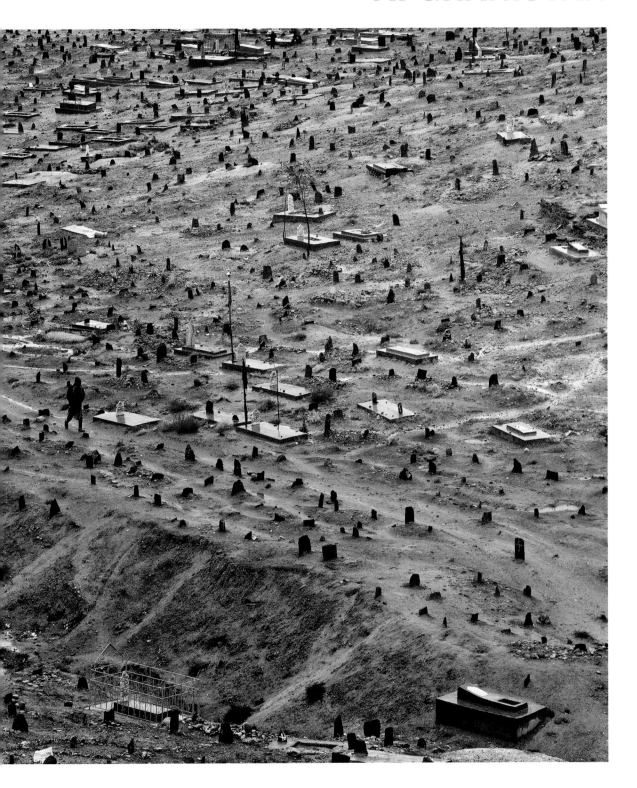

A patient at the Mental Health Hospital
is cared for by her aunt, Kabul, 2002

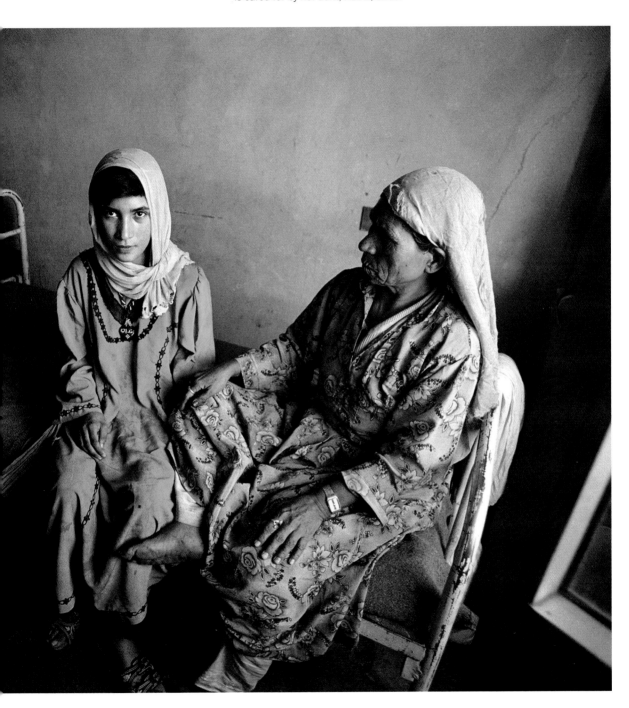

FRONTLINES | AFGHANISTAN

Under the Taliban, exercise was allowed but displays
of the body were forbidden, Majar-e-Sharif, 2002

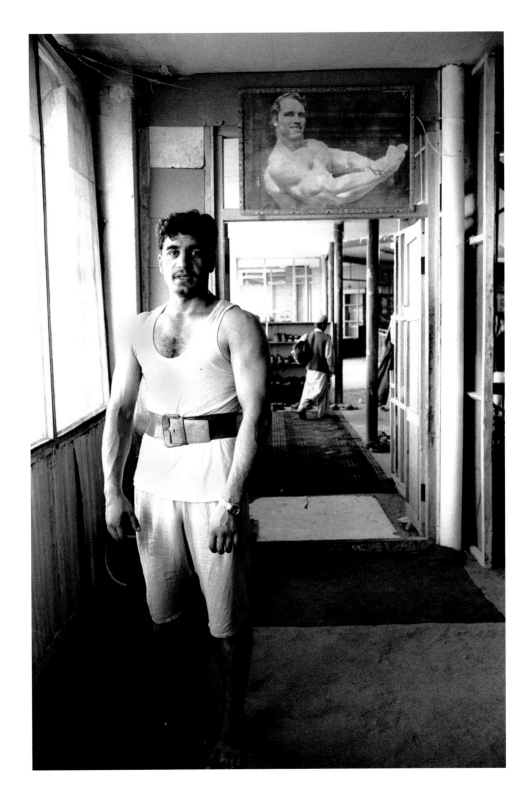

A heroin addict injects himself while his
younger brother looks on, Kabul, 2003

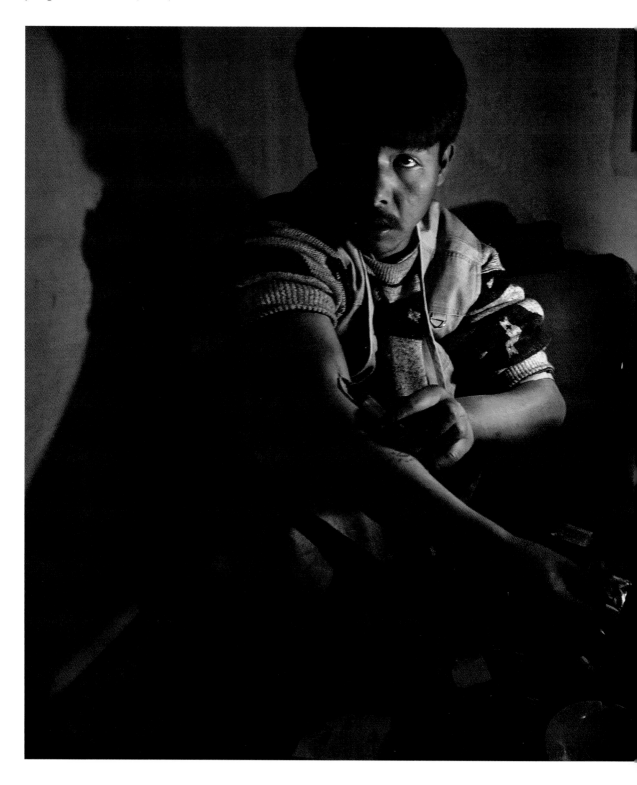

A 27-year-old Afghan heroin addict,
Kabul, 2003

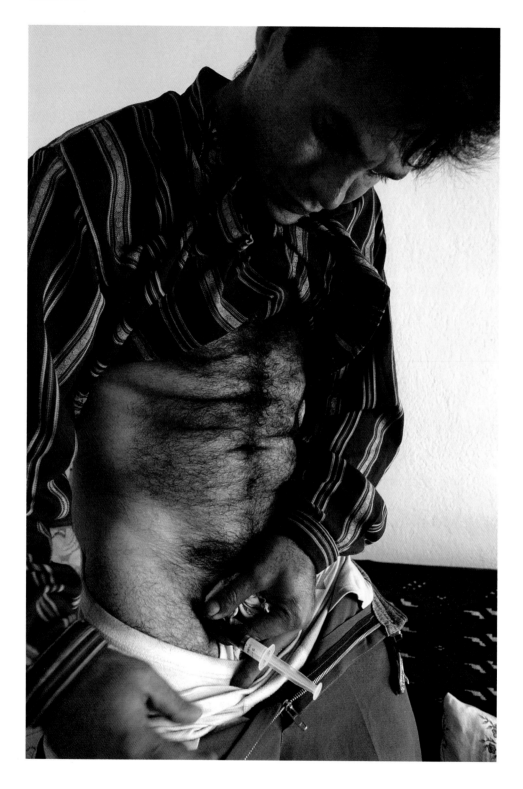

A heroin addict in the Mental
Health Hospital, Kabul, 2006

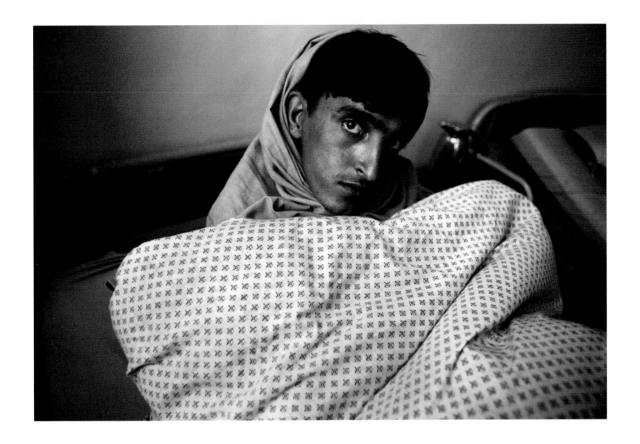

Dog-fighting, which was banned under the Taliban, is one of
the few forms of public entertainment and takes place in the
cooler winter months, outskirts of Kabul, 2006

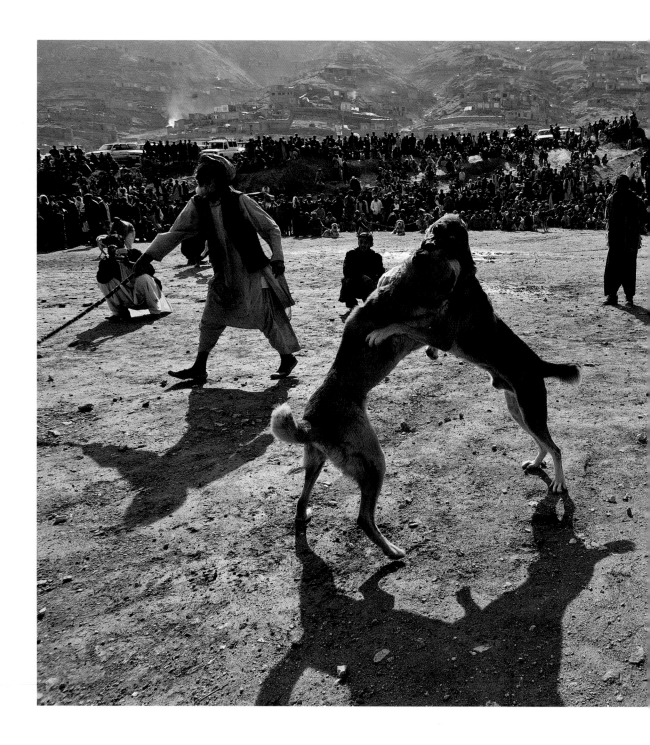

FRONTLINES | AFGHANISTAN

US military contractors drilling Afghan
police, Gereshk, Helmand, 2006

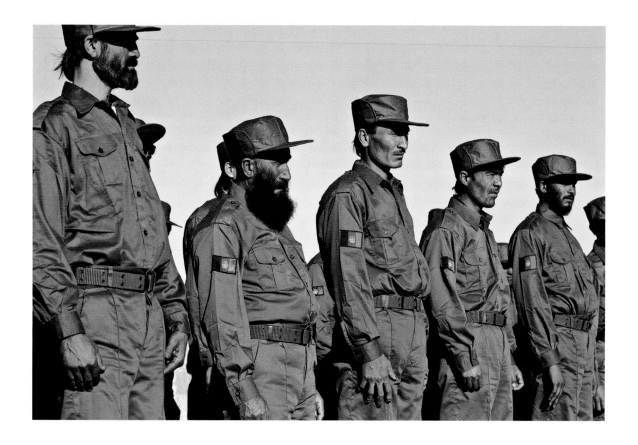

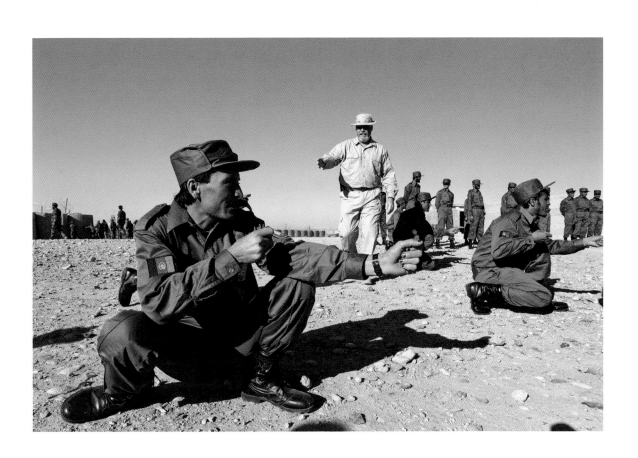

British Marine instructing Afghan police on
arrest techniques, Gereshk, Helmand, 2006

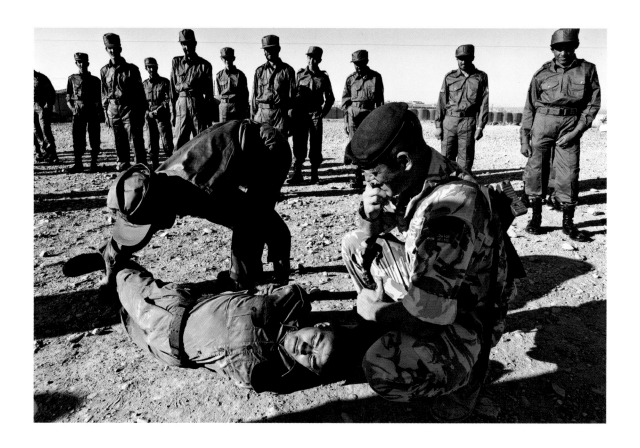

Young Afghan police recruit,
Gereshk, Helmand, 2006

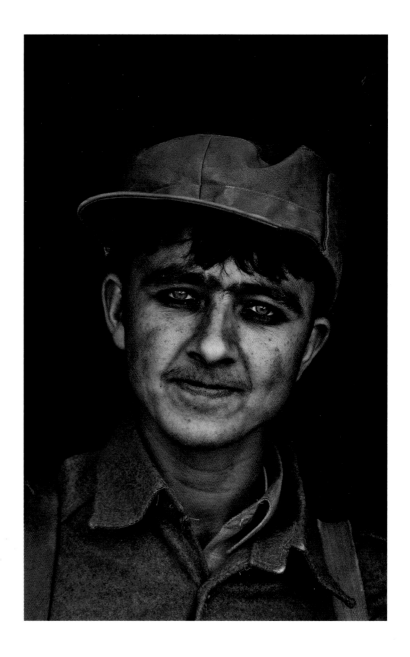

Women's wing of Pul-e-Charkhi Prison,
outskirts of Kabul, 2006

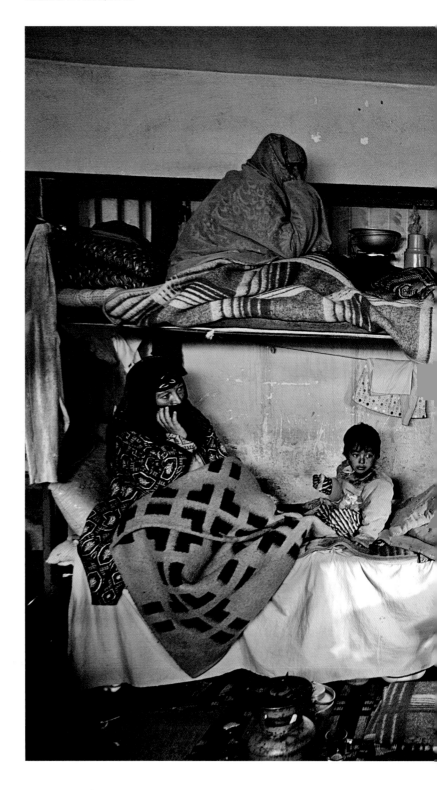

FRONTLINES | AFGHANISTAN

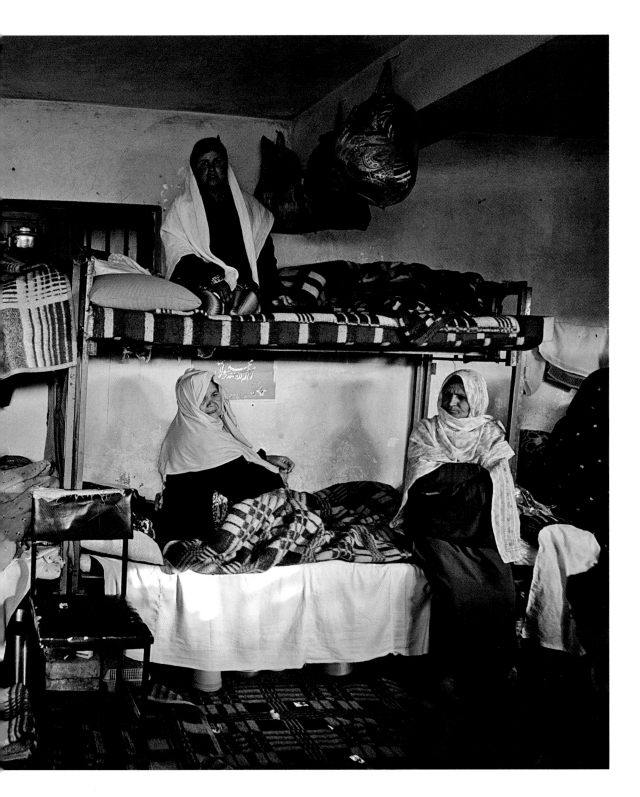

Despite the enormous strain put on the Iraqi infrastructure by more than a decade of international sanctions, normal life carried on for many Iraqis in the months leading up to the US-led invasion. However, once US troops arrived in Baghdad the country's comparative stability was shattered.

Prior to the invasion, reporting from Iraq had been extremely difficult – visas had to be renewed regularly and foreign journalists had to work out of the Ministry of Information in Baghdad. Bulky, battery-operated satellite phones were the only means of communication with London and they could only be used when in alignment with a satellite. Although digital cameras were fairly standard by 2003, storage cards were limited to one gigabit of memory, forcing photographers to delete material continually. During the invasion, the Ministry of Information was hit by a missile and journalists were moved to the Palestine Hotel.

For the November 2005 trip, Smith was embedded with the US Marines in Al Anbar province (western Iraq), near the Syrian border. The marines were part of Operation Steel Curtain, a US offensive designed to break up insurgent cells and disrupt supply lines from Syria. The marines worked their way through the border towns along the Euphrates, meeting with the most resistance in the town of Ubaydi.

Wedding, Baghdad, 2003

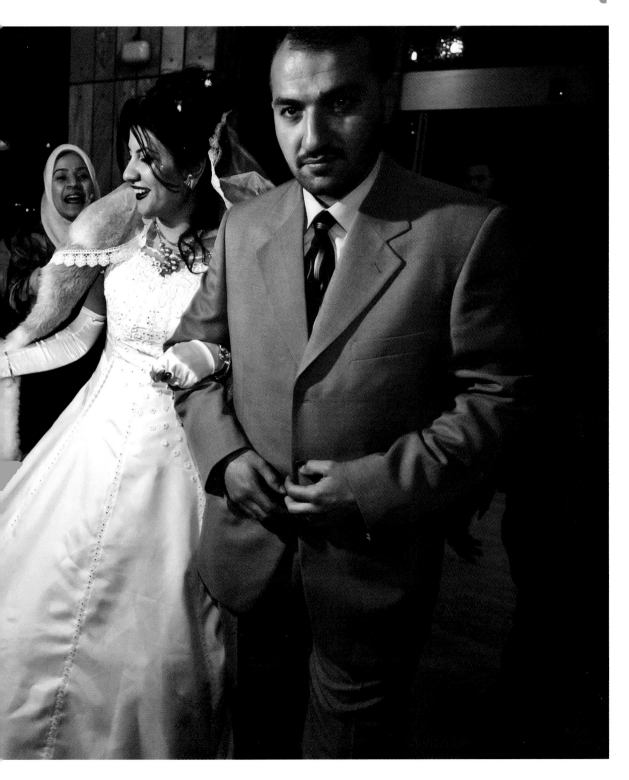

In the months leading up the invasion, normal life carried
on, including at the racetrack, Baghdad, 2003

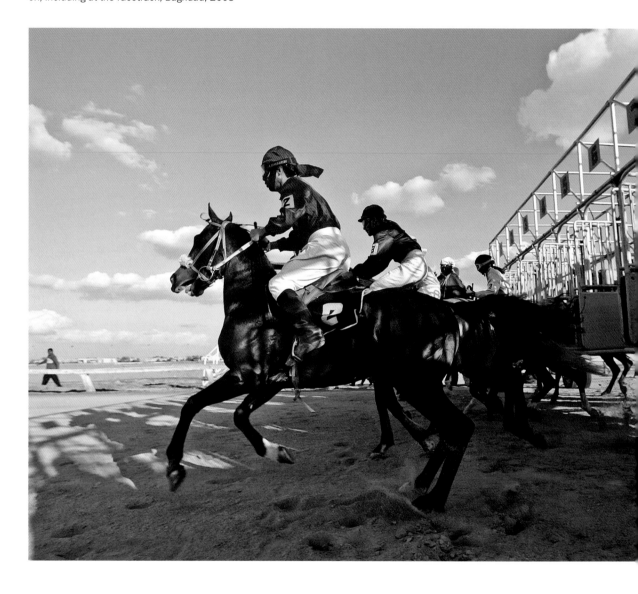

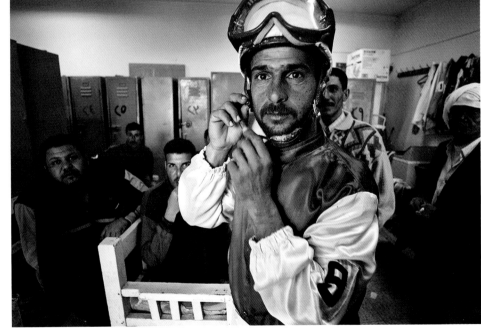

Ceremony to mark the 12th anniversary of the US missile attack on
Al Amiriya during the 1991 war in which hundreds of people died,
Tomb of the Unknown Martyr, Baghdad, 2003

Parade in support of Saddam Hussein,
Mosul, 2003

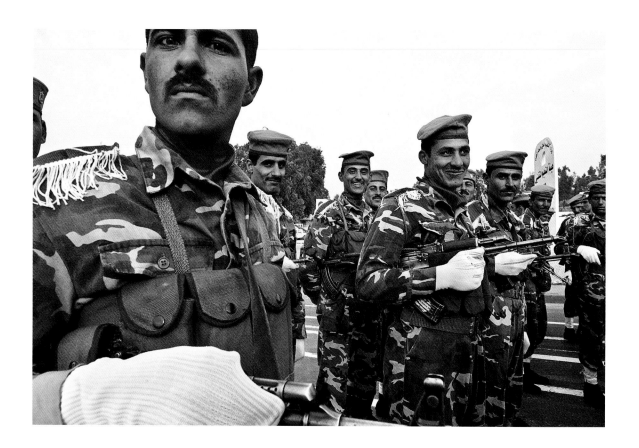

FRONTLINES | IRAQ

Parade in support of Saddam Hussein, one of the last before
the US invasion, in his home town of Tikrit, 2003

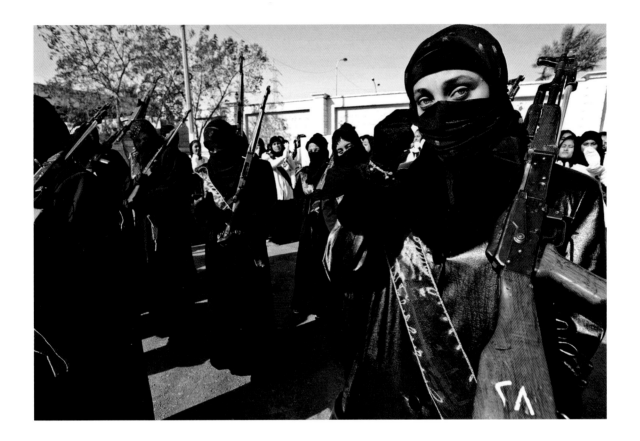

Child dressed in Iraqi army uniform. The US bombing
had begun 11 days earlier. Baghdad, 2003

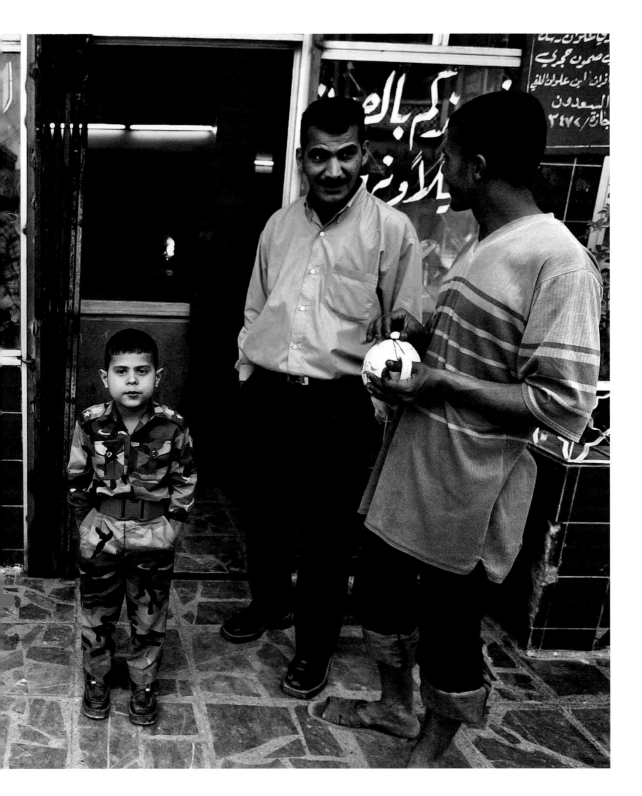

Tariq Aziz leaving a press conference in
the Palestine Hotel, Baghdad, 2003

Vice President Taha Yassin Ramadam at the Tomb of the Unknown Martyr, to mark
the 12th anniversary of the US missile attack on Al Amiriya, Baghdad, 2003

Last large scale demonstration against the invasion
and in support of Saddam Hussein, Baghdad, 2003

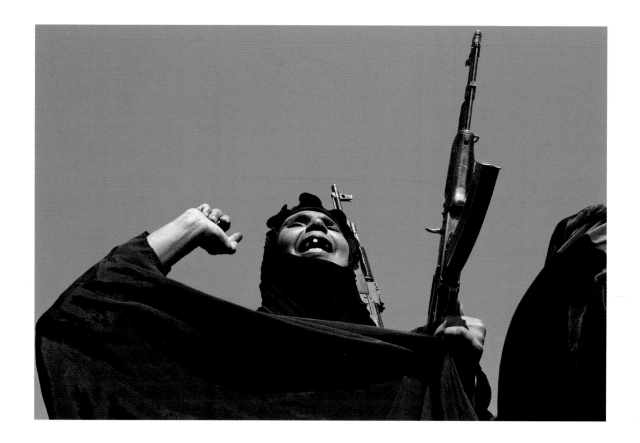

Sales of Valium and other anti-anxiety medicines soared in
the months leading up to the US invasion, Baghdad, 2003

An A10 tank buster over the city as
US soldiers enter Baghdad, 2003

FRONTLINES | IRAQ

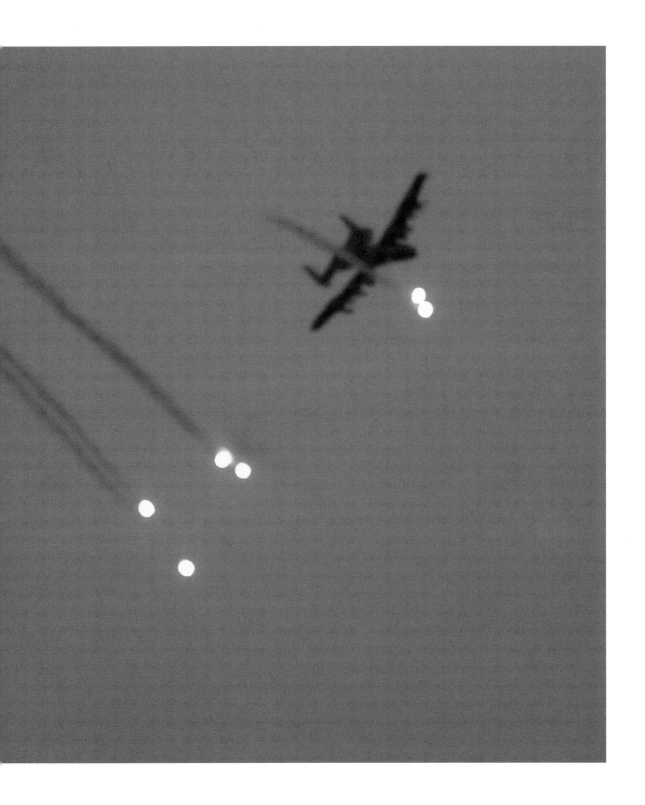

As US forces enter the outskirts of the capital,
local families flee, Baghdad, 2003

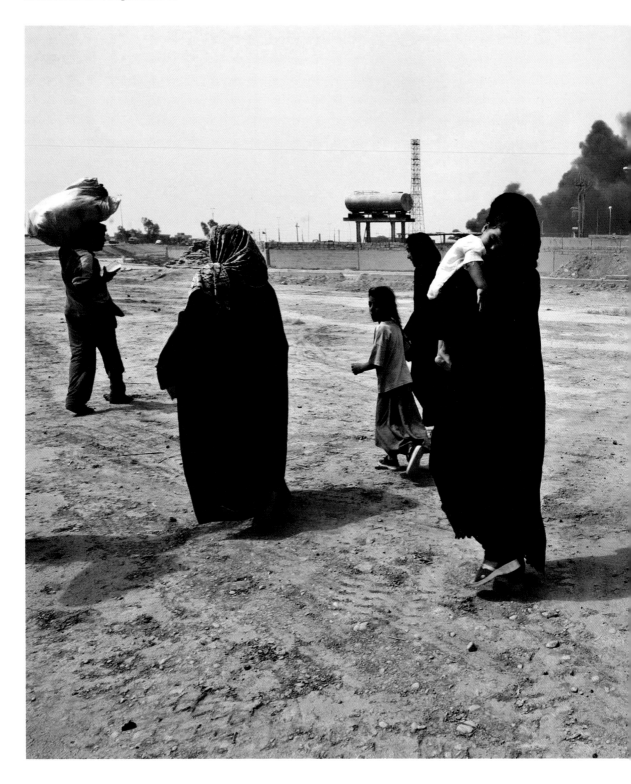

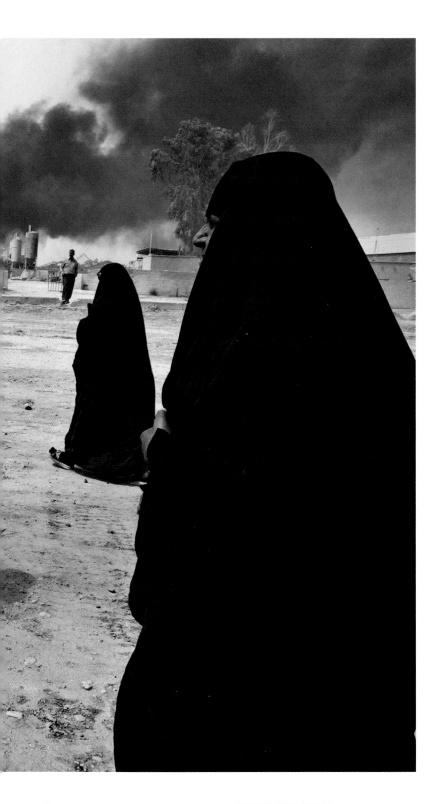

During the initial incursion into the capital,
a US tank is destroyed, Baghdad, 2003

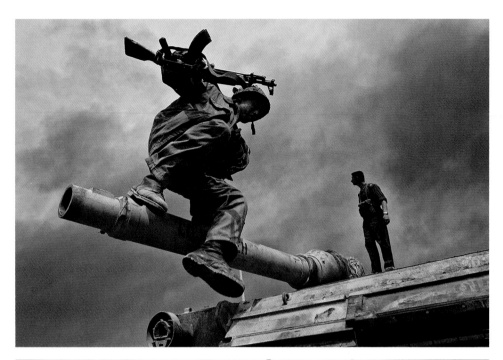

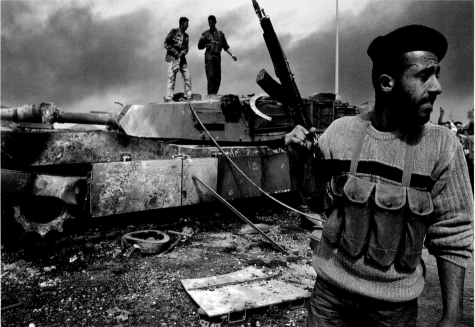

Three Iraqi soldiers near the destroyed
tank in slip trenches, Baghdad, 2003

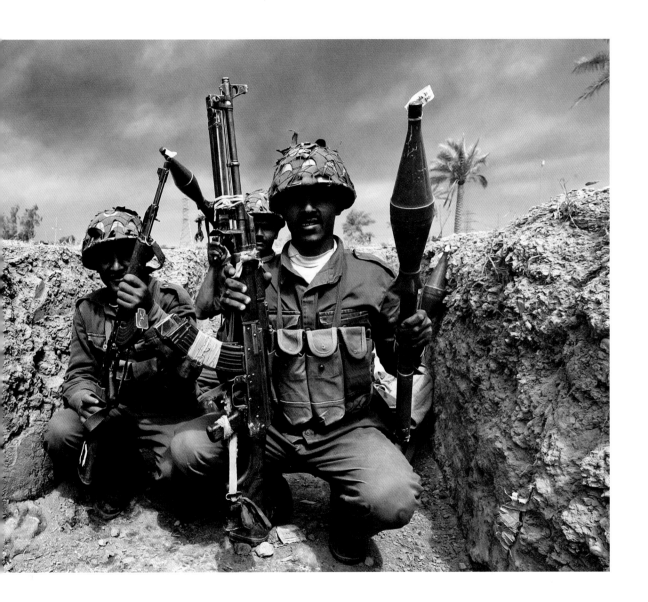

US Marines reach the centre of Baghdad and topple the statue
of Saddam Hussein outside the Palestine Hotel, 2003

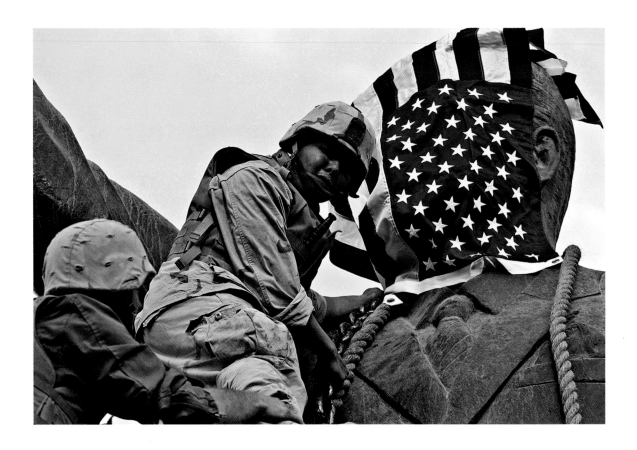

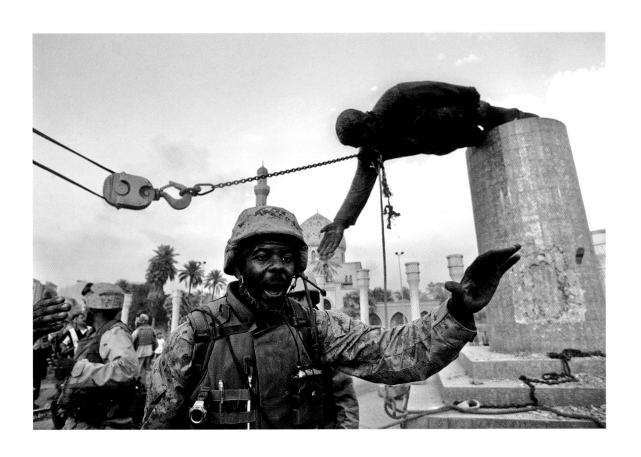

US soldier Felcia Harris in the master bedroom of
one of Uday Hussein's houses in the presidential
compound, Baghdad, 2003

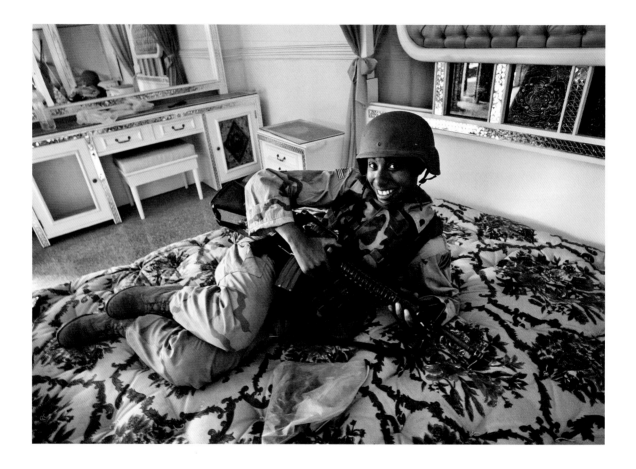

A child recovers a pet rabbit from his bomb
damaged neighbourhood, Baghdad, 2003

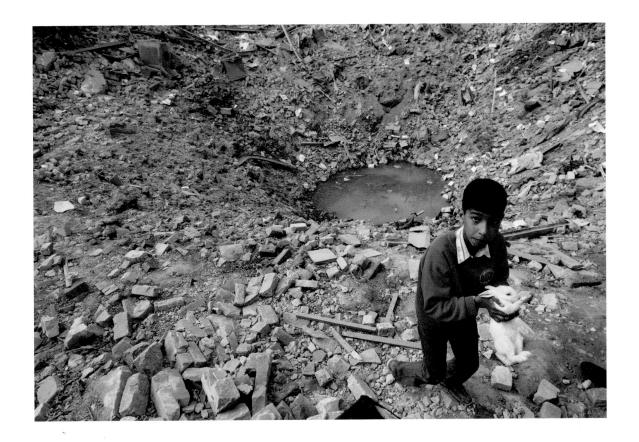

Lorry being used as makeshift mortuary,
Baghdad, 2003

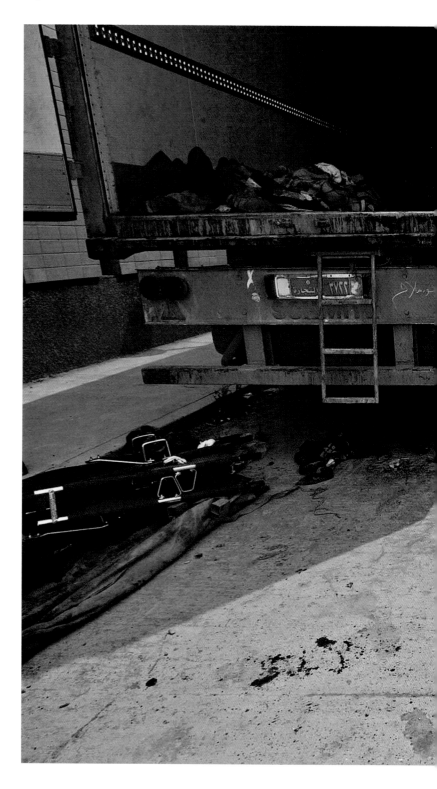

FRONTLINES | IRAQ

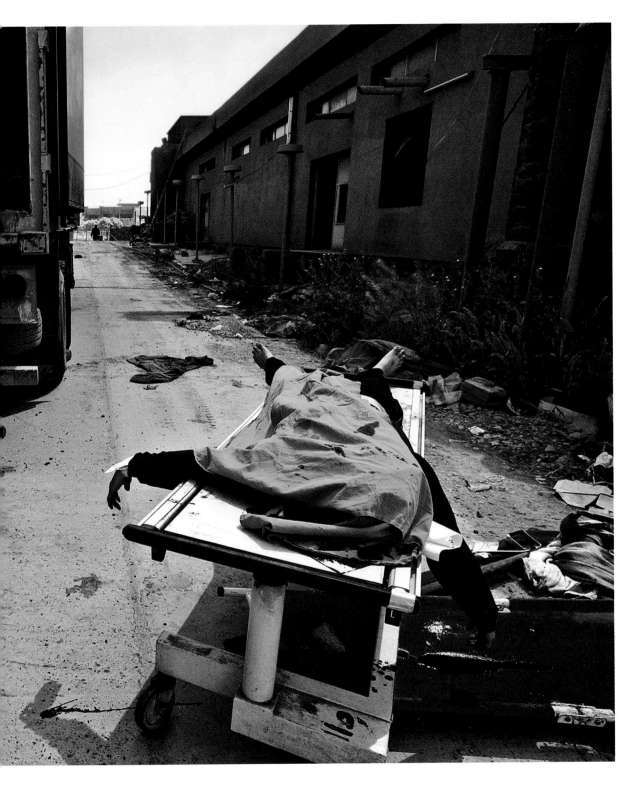

US soldiers begin to clear and bury the decomposing bodies
inside the presidential compound, Baghdad, 2003

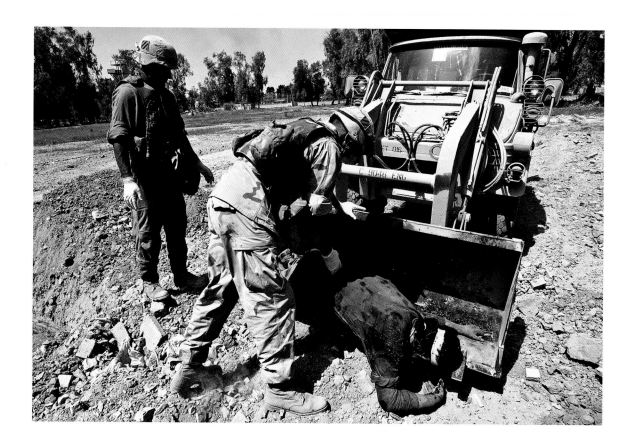

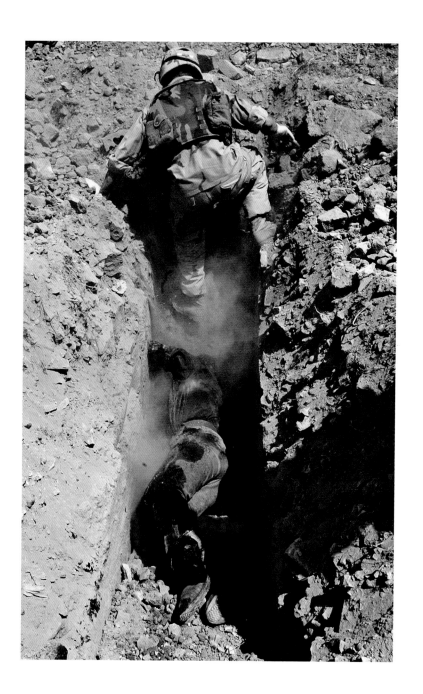

A team of Iraqi volunteers, who have returned to Yarmouk Hospital to bury decomposing bodies from the mortuary, treat a civilian caught in crossfire outside. The hospital had been looted and has been without electricity for weeks. Baghdad, 2003

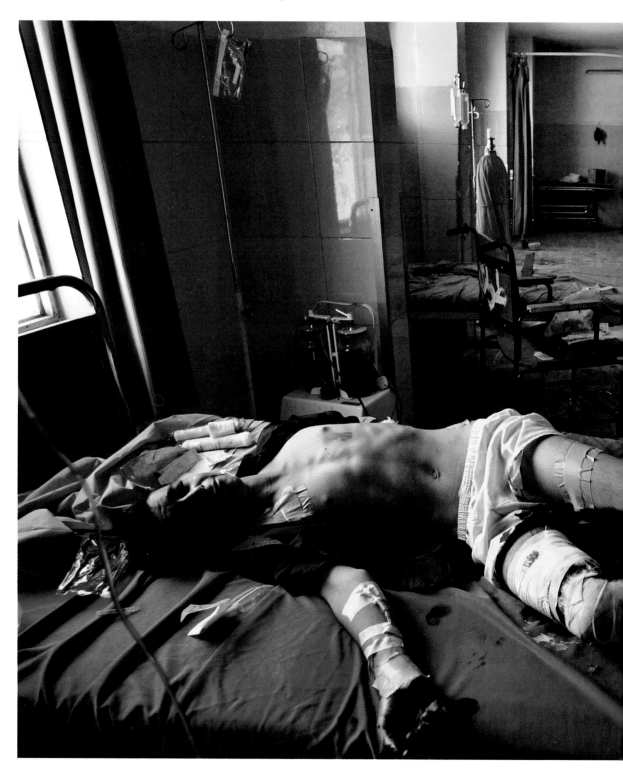

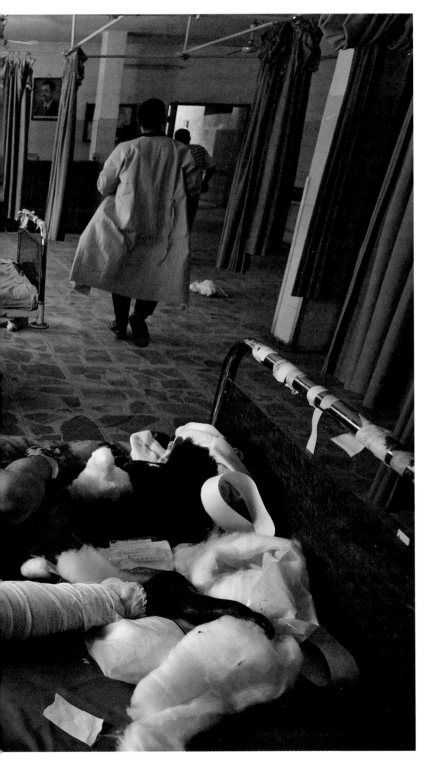

Iraqi volunteers bury decomposing bodies from the
mortuary of Yarmouk Hospital, Baghdad, 2003

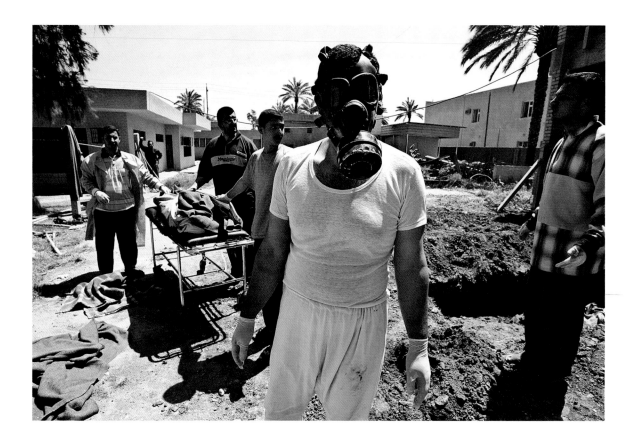

Civilians from Saddam City, the mainly Shia area of Baghdad, with
weapons looted from Ba'ath Party buildings, Baghdad, 2003

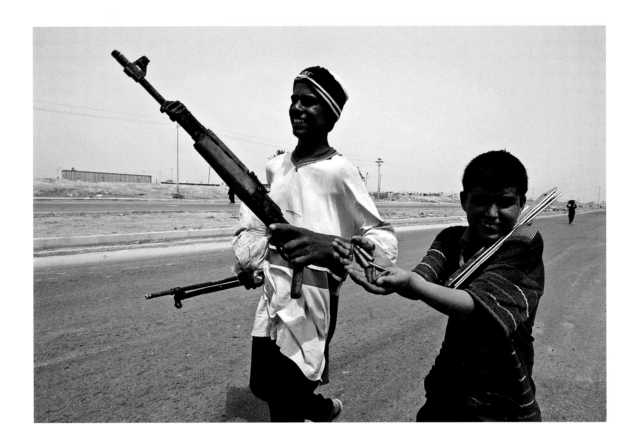

A boy gets treatment for epilepsy at Ibn Rushd
Mental Health Hospital, Baghdad, 2003

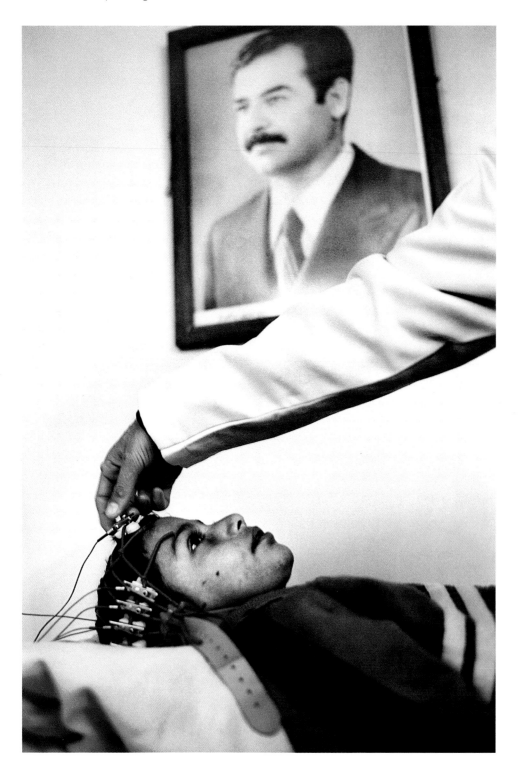

Patients at Al Rashad Mental Health Hospital which had
been completely looted after the invasion, Baghdad, 2003

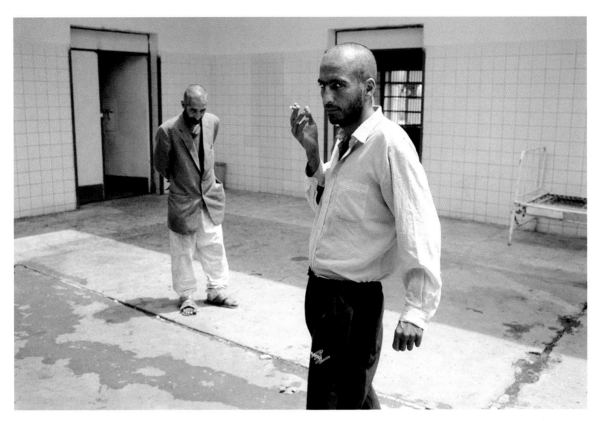

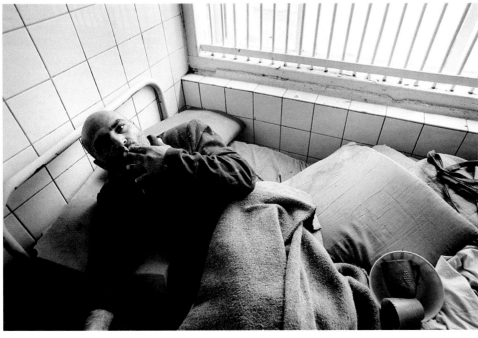

Operation Steel Curtain was designed to disrupt the flow of car
bombs and weapons to Baghdad in the lead up to the elections
in December 2005. US Marines close to the Syrian border, 2005

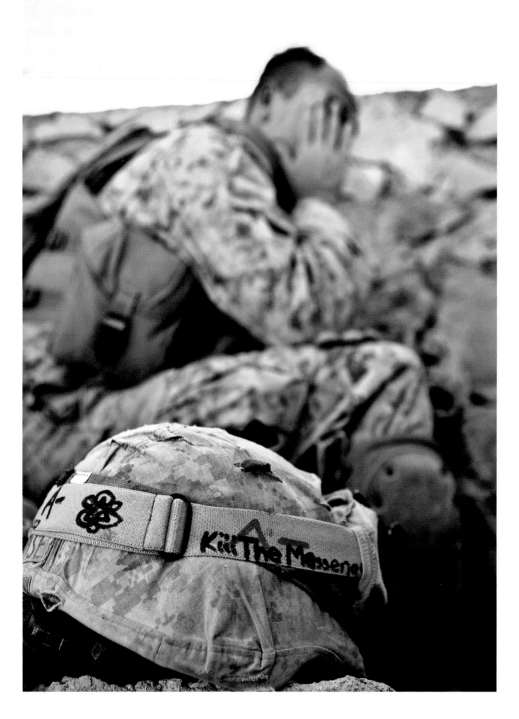

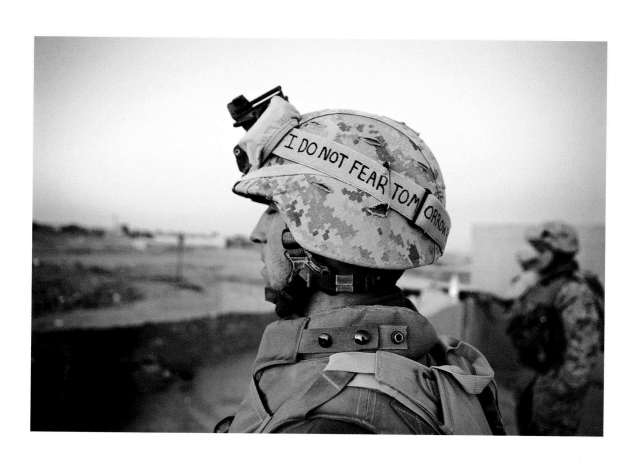

FRONTLINES | IRAQ

US Marines involved in Operation Steel
Curtain in the towns of Karabilah and
Husaybah on the Syrian border, 2005

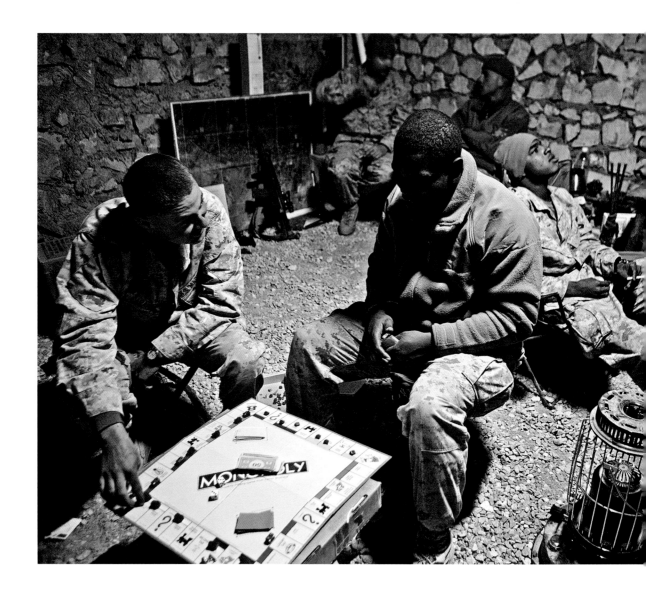

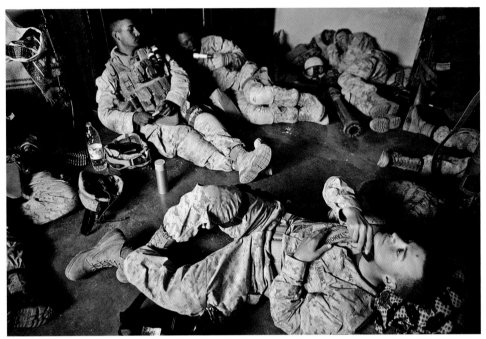

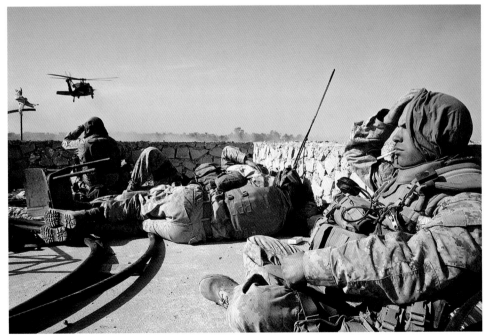

US Marines occupy the town of Husaybah
on the Syrian border, 2005

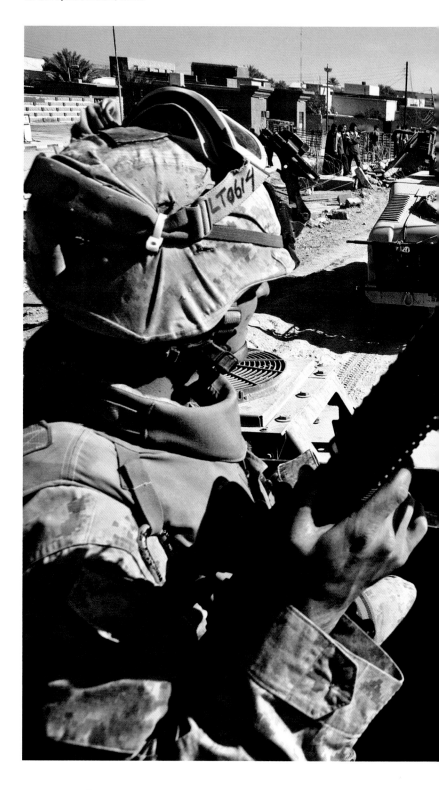

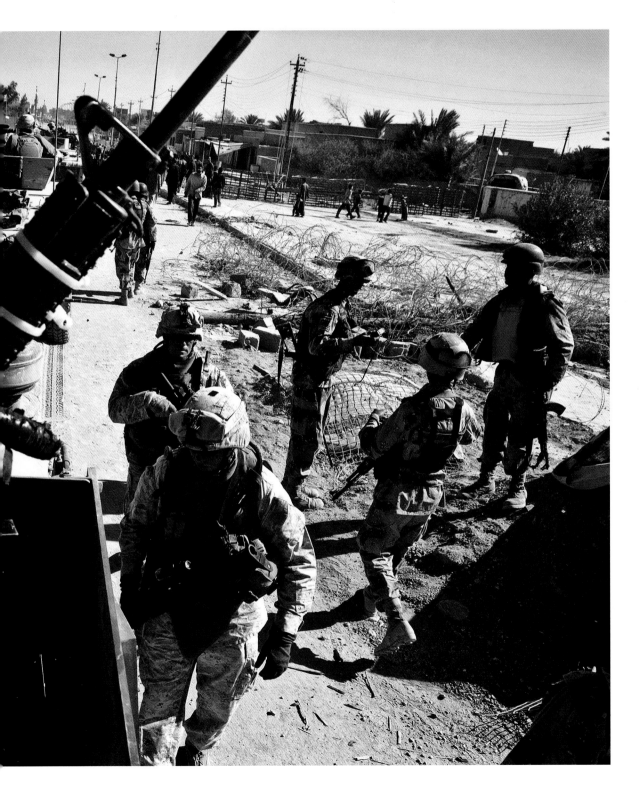

US Marines and Iraqi army carry out
house-to-house searches in Ubaydi, 2005

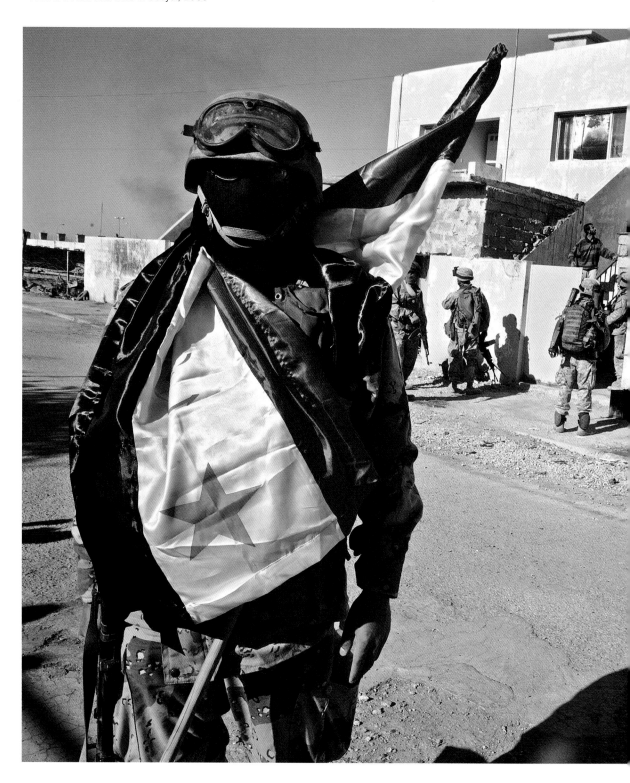

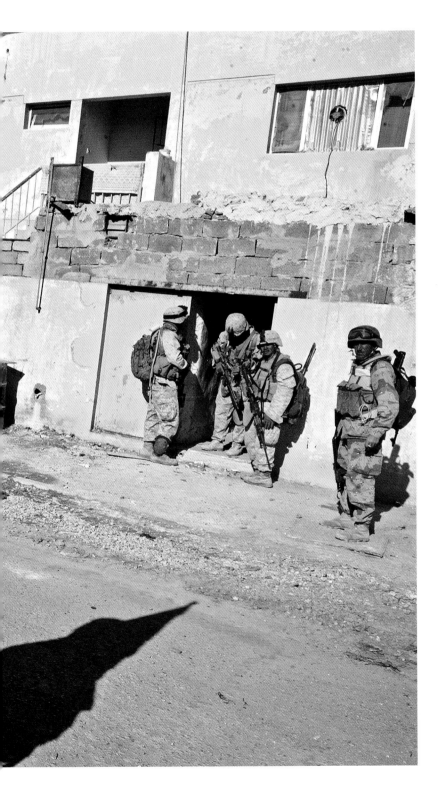

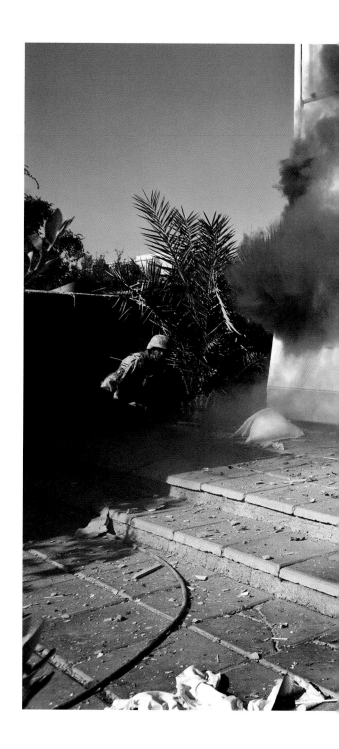

US Marines storm a house from which they
have been under attack, Ubaydi, 2005

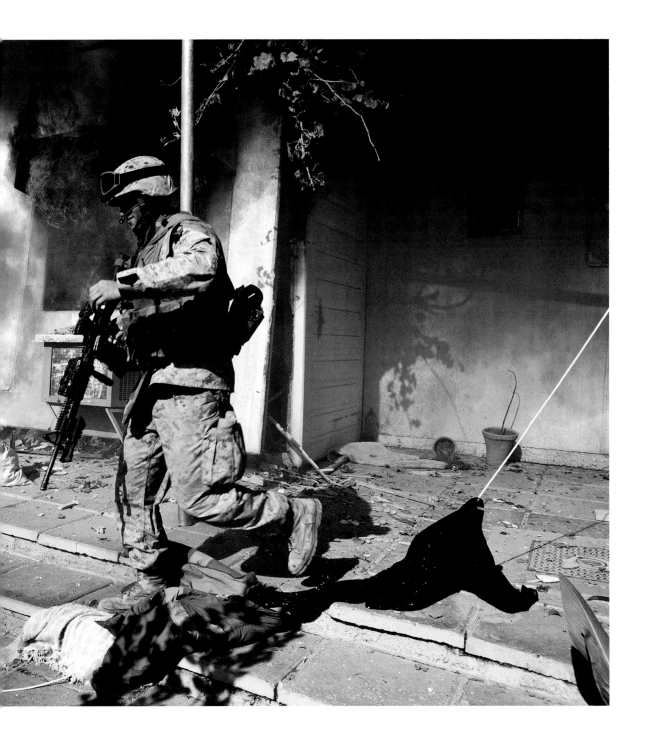

US Marines take the town of Ubaydi, 2005

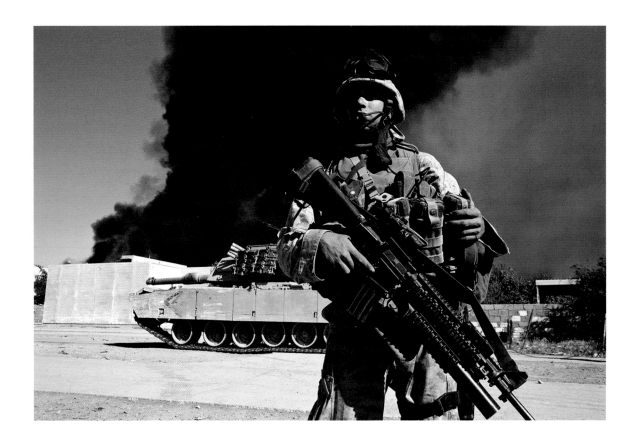

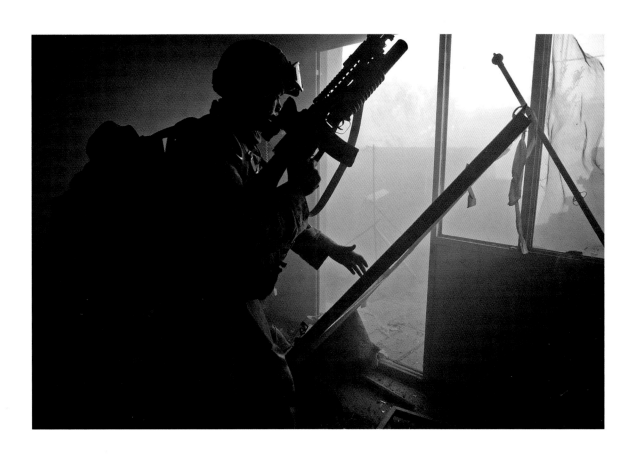

US Marines take the town of Ubaydi, 2005

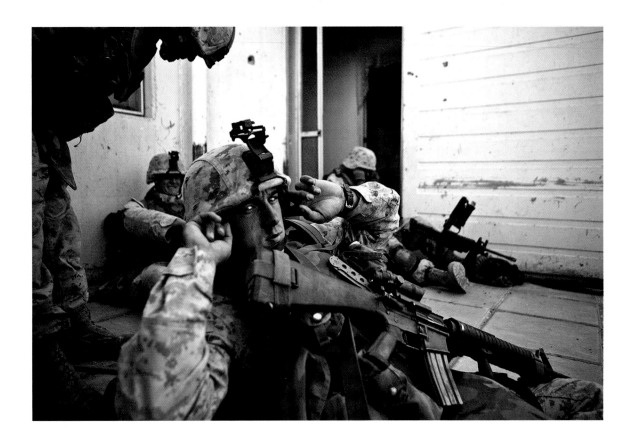

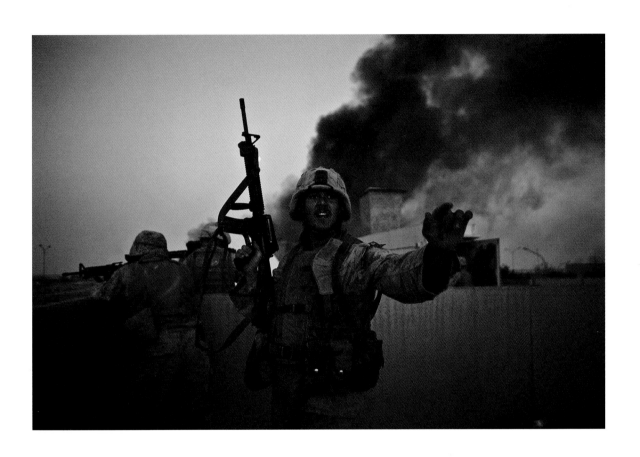

Woman caught in the fighting,
Ubaydi, 2005

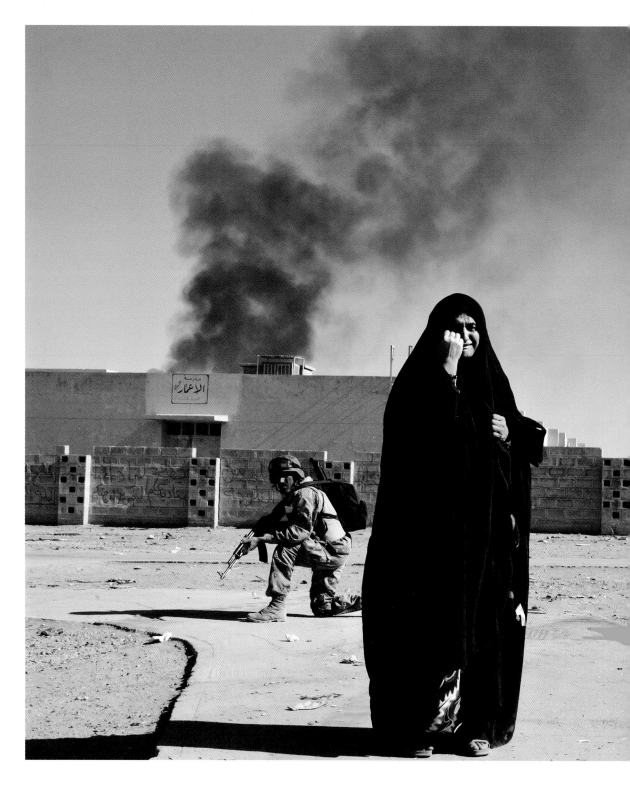

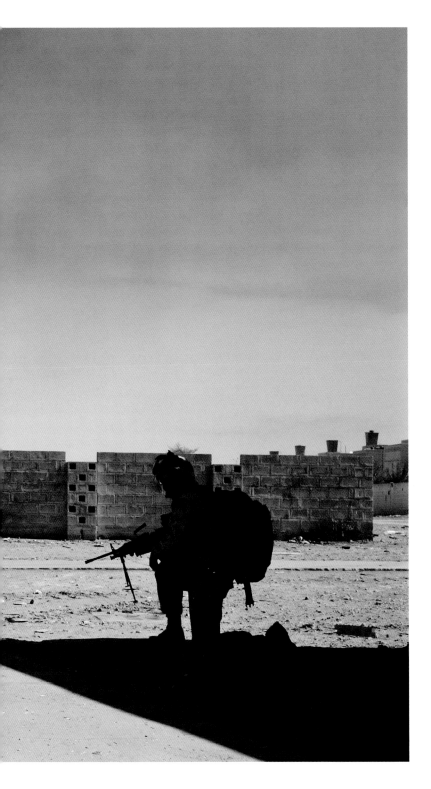

As the Marines advance through the town, residents caught up in the fighting flee their homes. As they reach the US line, men and teenage boys are separated from women and children. Ubaydi, 2005

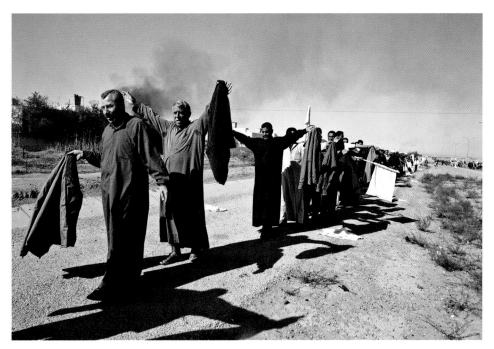

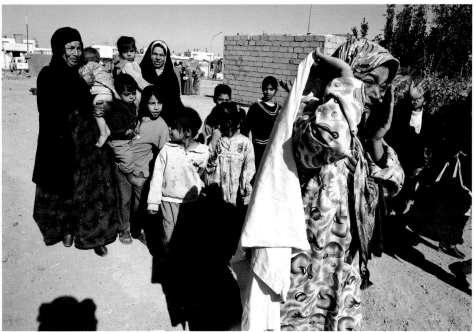

 FRONTLINES | IRAQ

A distressed child resists being separated
from his father, Ubaydi, 2005

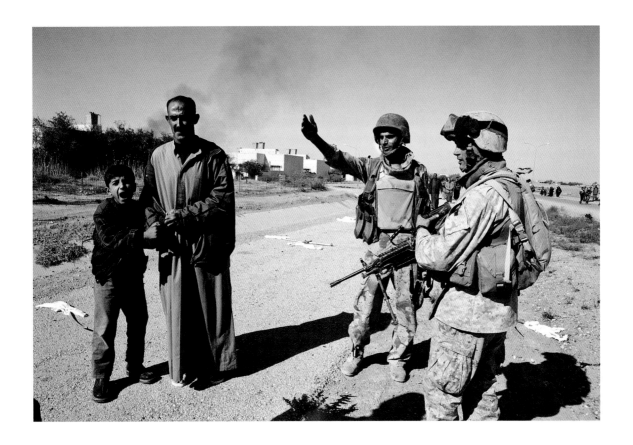

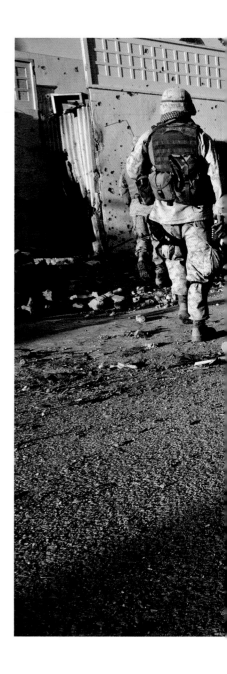

Dead insurgent, Ubaydi, 2005

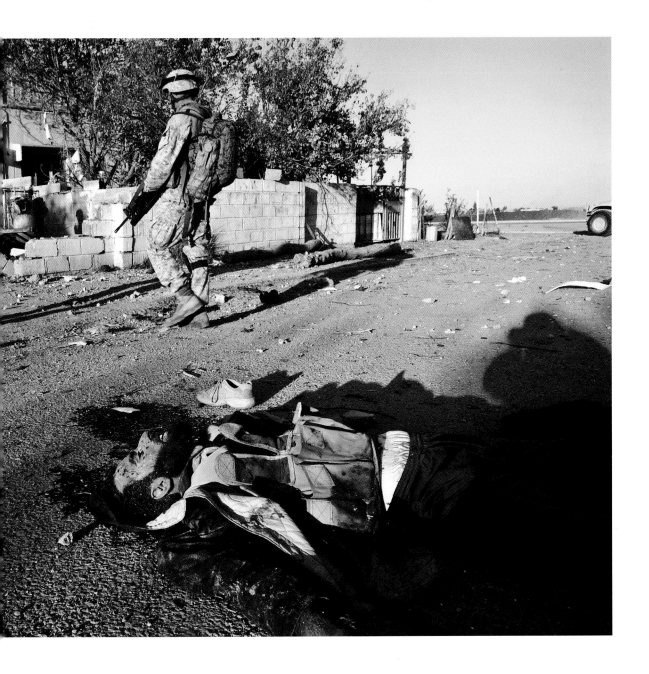

Displaced residents head into
the desert, Ubaydi, 2005

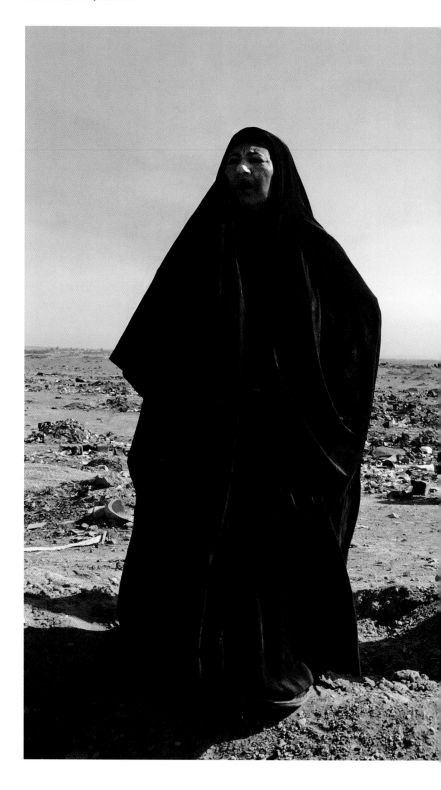

FRONTLINES | IRAQ

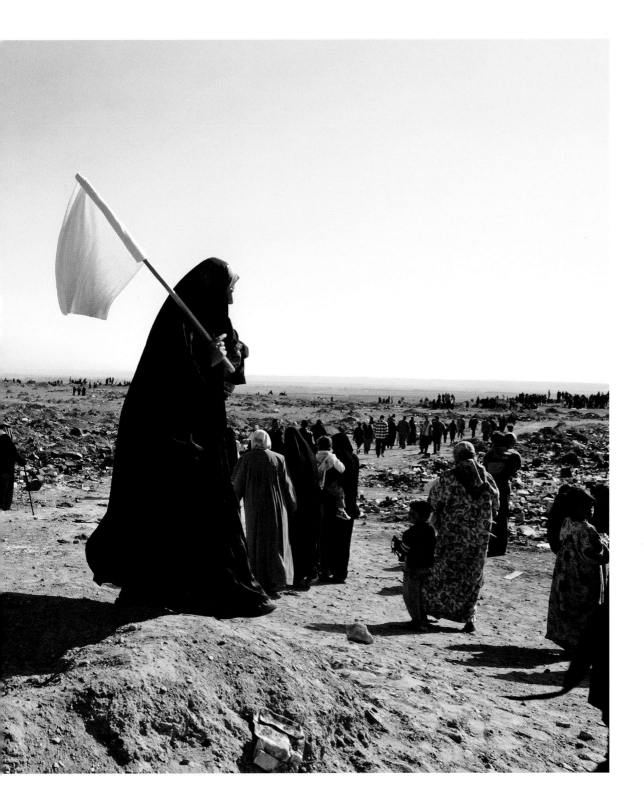

FRONTLINES | IRAQ

Suspected insurgents captured by US Marines at the end of Operation
Steel Curtain, Euphrates river, close to Syrian border, 2005

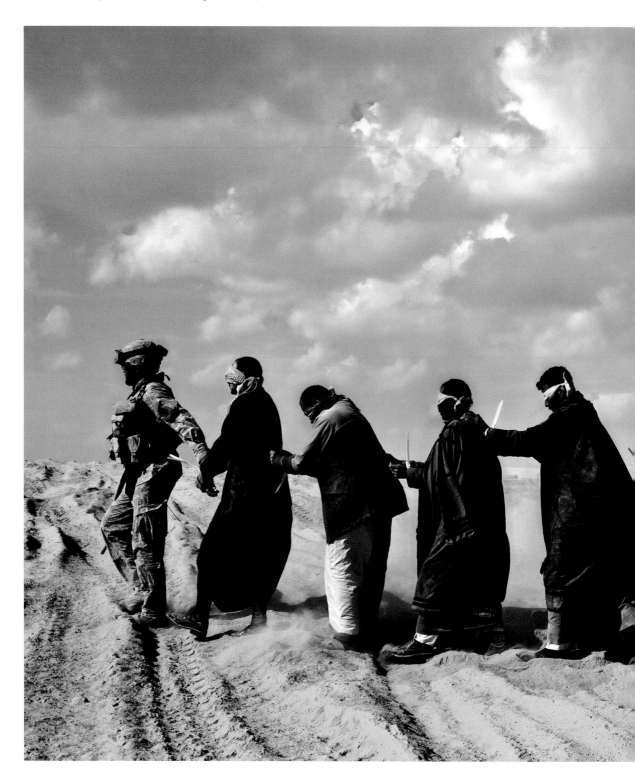

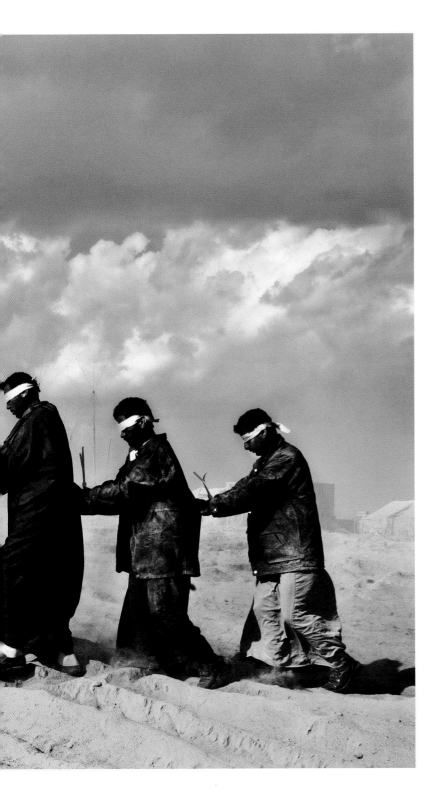

FRONTLINES | IRAQ

LEBANON

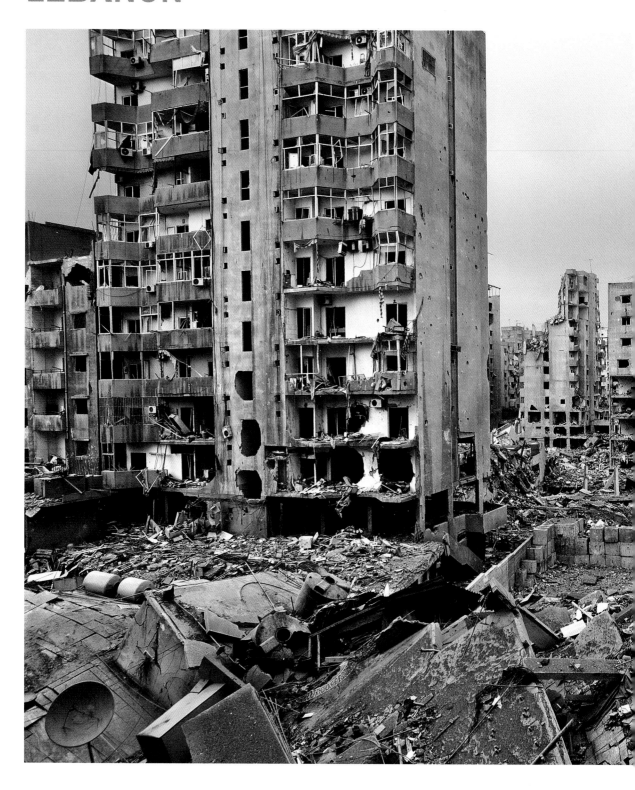

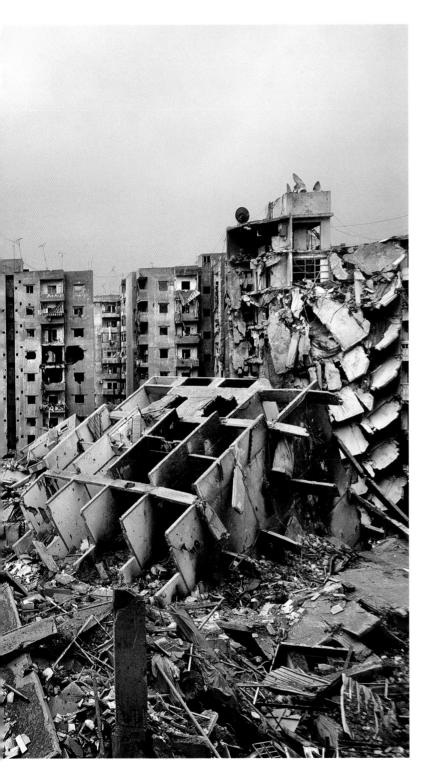

On 12 July 2006 Hezbollah attacked an Israeli patrol, killing three soldiers and capturing two more. Israel responded with a massive air and sea bombardment, causing extensive damage to the civilian infrastructure. Villages close to the border with Israel suffered particularly badly, with the UN estimating that between 35 and 40 per cent of the inhabitants were either too frail or poor to flee. By mid-August, when a UN-sponsored ceasefire was brokered, approximately 160 Israelis – mostly soldiers – and 1,000 Lebanese were dead.

Rubble of buildings destroyed by Israeli bombing, southern suburbs of Beirut, 2006

Elderly couple, who were unable to flee when fighting started,
waiting to be evacuated by the Red Cross and UN, Tyre, 2006

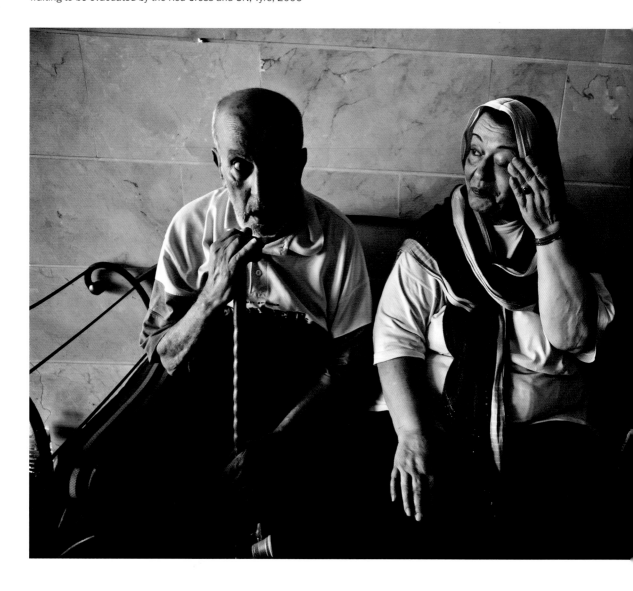

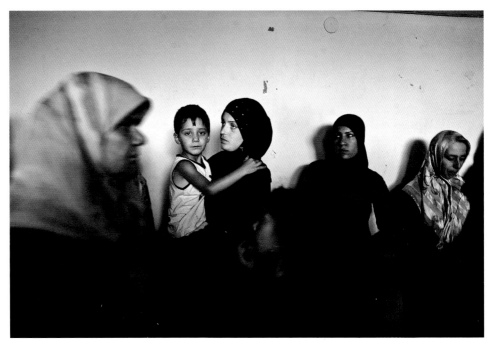

Civilians taking shelter in a hospital during fighting between Israel and Hizbullah, Tibnine, 2006

During a lull in the fighting, the elderly and
infirm try to reach safety, Bint Jbeil, 2006

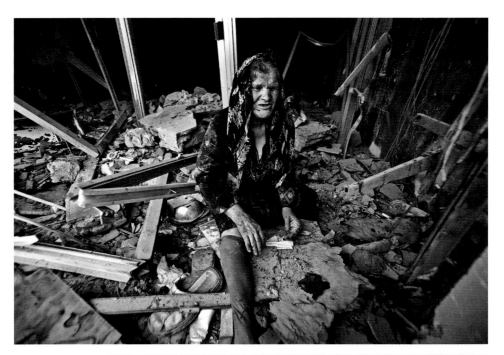

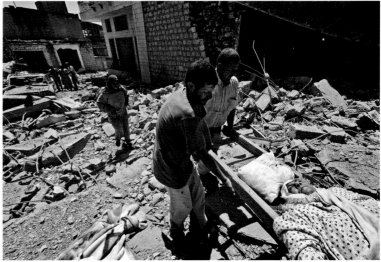

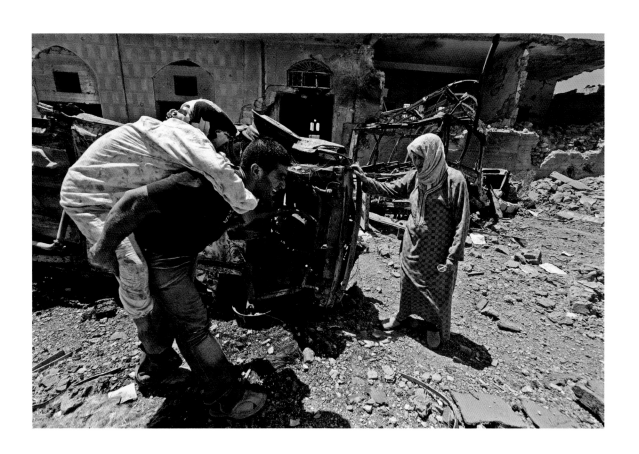

With a total absence of emergency
services, an elderly and infirm man
waits for assistance, Bint Jbeil, 2006

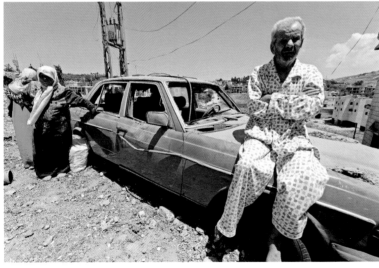

Refugees, who have been trapped by the
hostilities, fleeing the village of Aitaroun, 2006

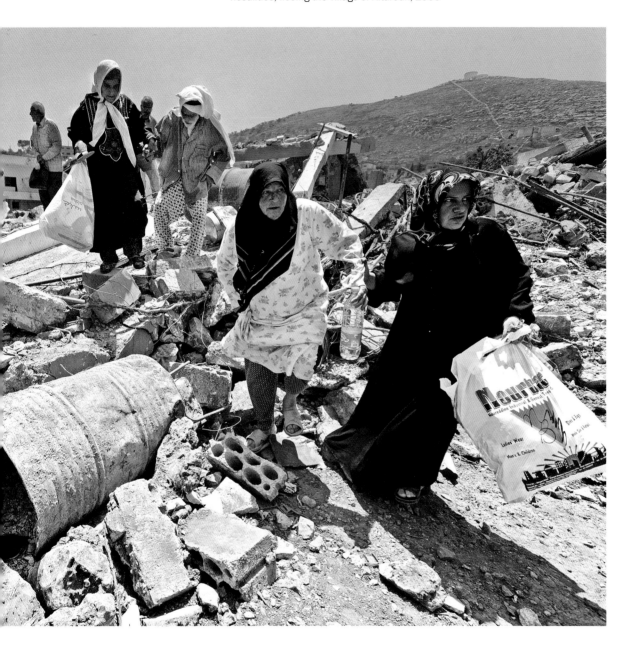

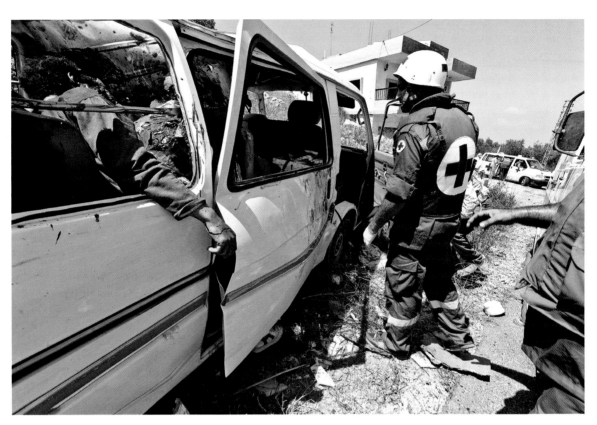

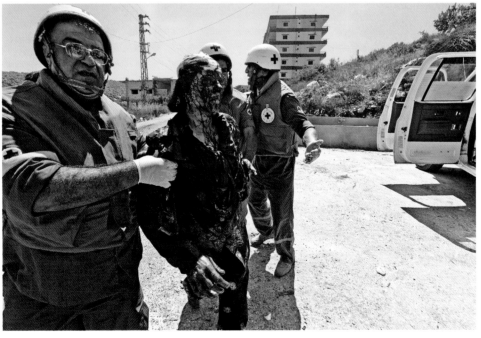

Red Cross workers come across the Sha'ita family who were
fleeing north from the village of Et Tiri when their vehicle was
hit by an Israeli air attack, near Qana, on the road to Tyre, 2006

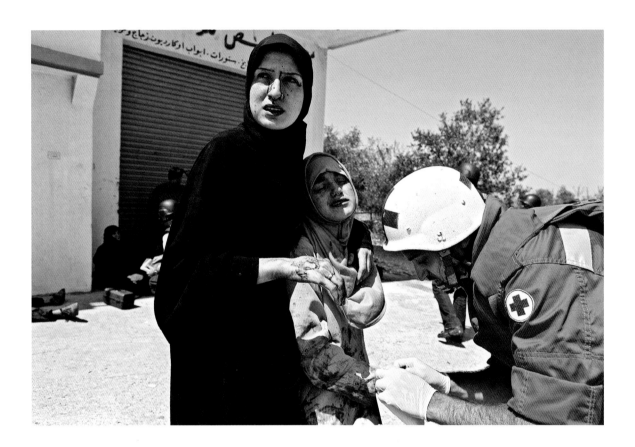

Bodies of victims of Israeli bombing, including UN personnel, are recovered by Lebanese soldiers during a ceasefire, placed in coffins, and moved to Beirut. Tyre, 2006

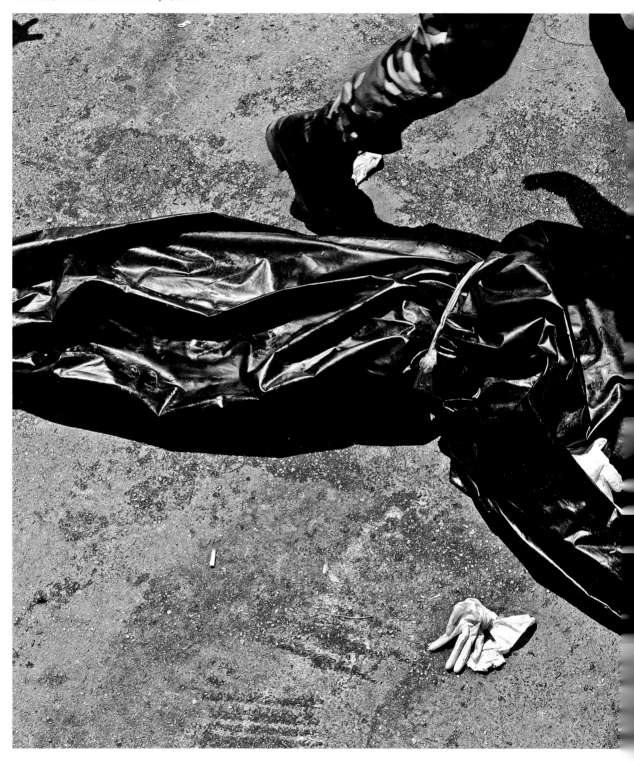

Villagers, who have been trapped by the fighting for weeks, fleeing during a lull in the hostilities, Aitaroun, 2006

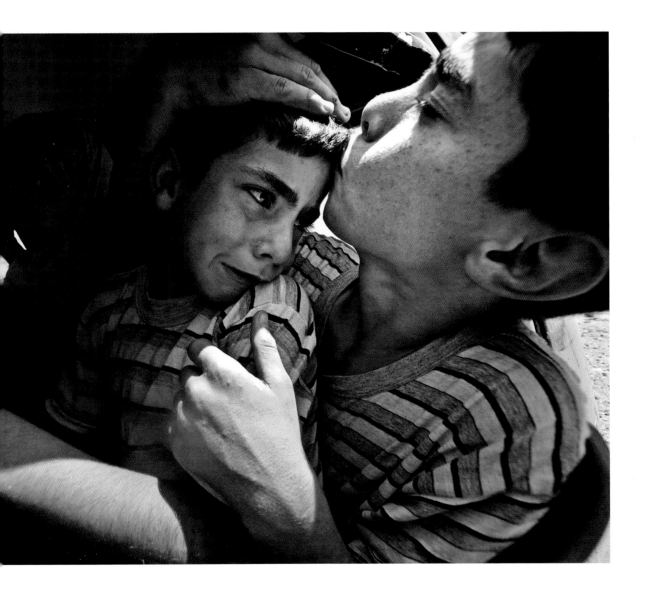

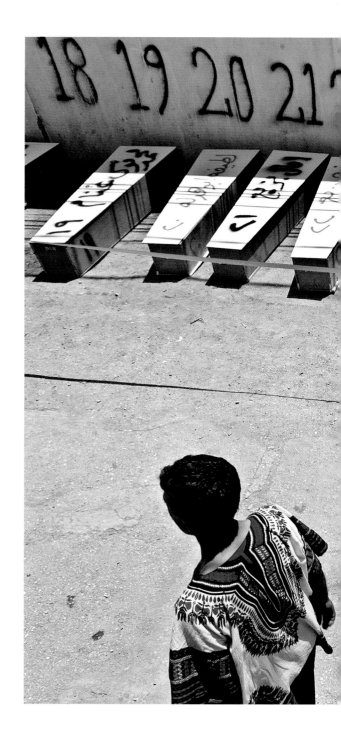

Many of the recovered bodies remained unclaimed because of the ongoing Israeli threat to attack all movement south of the Latani river. As the unclaimed body count increased and with no appropriate place to store them, mass burials are carried out. Tyre, 2006

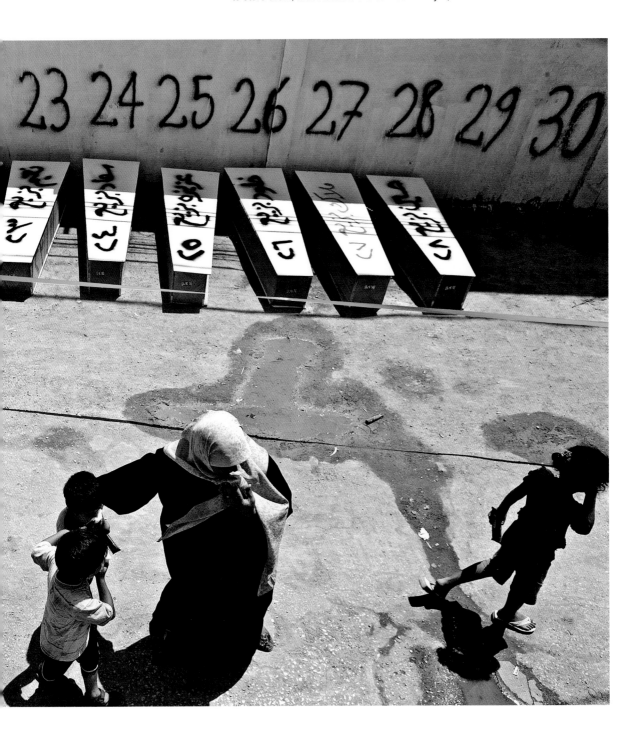

Night-time, mass burial of victims of the Israeli bombardment. Some of the dead were subsequently exhumed by their families. Tyre, 2006

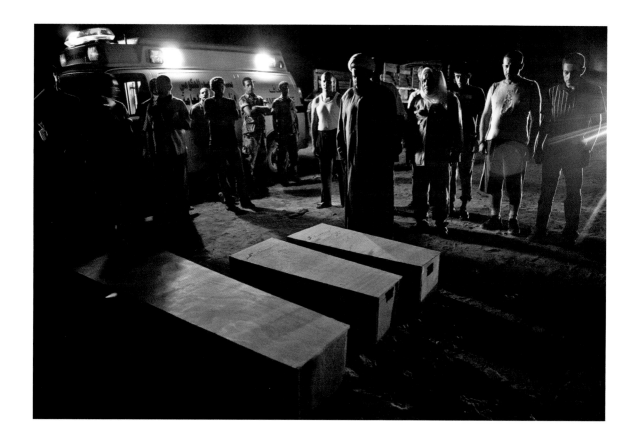

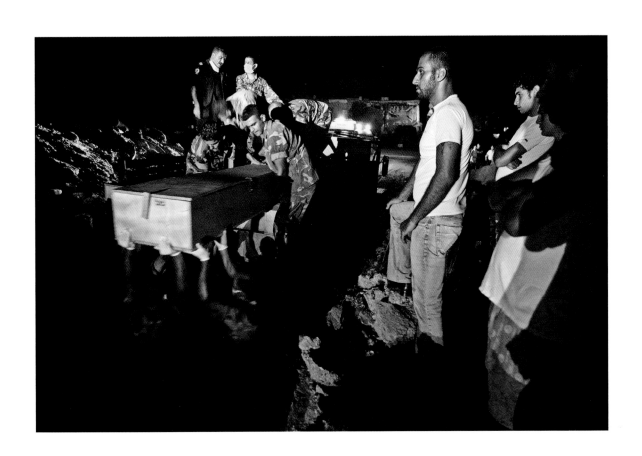

12-year-old Ali Sha'ita comforts his mother in the wake of an Israeli air attack on the vehicle in which he and his family were fleeing the village of Et Tiri, Tyre, 2006

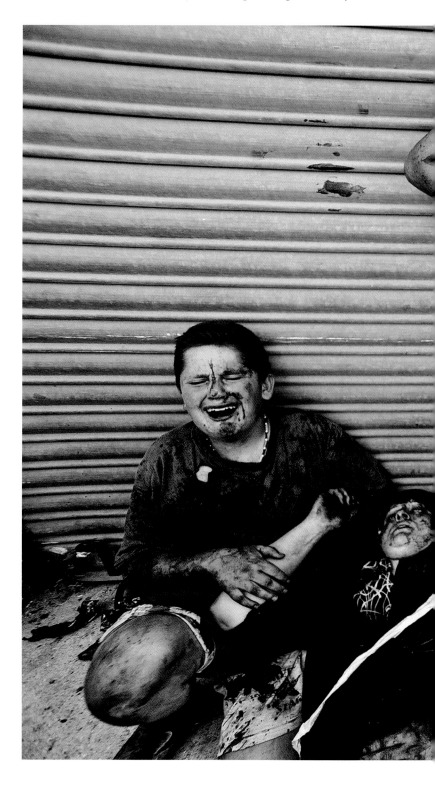

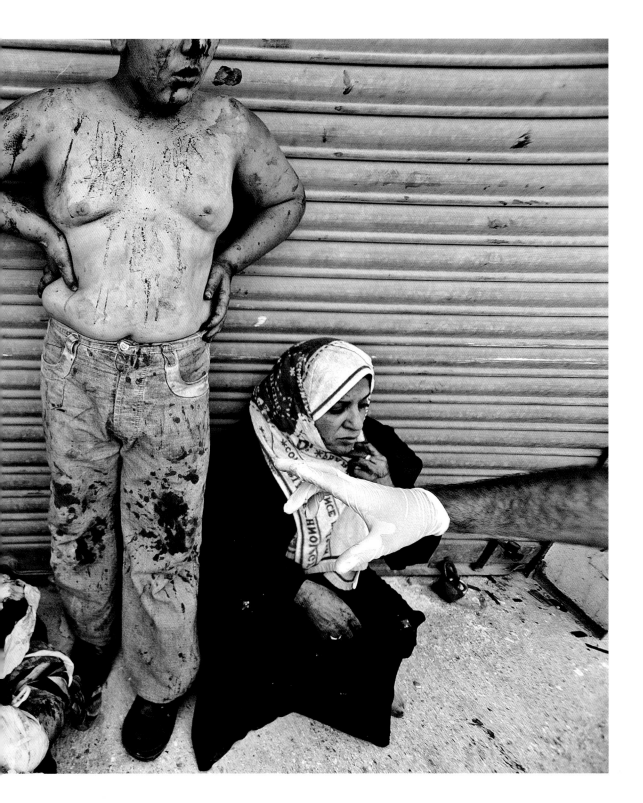

In 2006, Smith was embedded with the 101st Airborne Division around Tikrit and Hawija, an area north of Baghdad with a majority Sunni population. Tikrit was Saddam Hussein's birthplace and was viewed by US forces as an important source of funding for insurgency. They were accordingly suspicious of anyone whose papers identified them as not being local. There was also a lack of trust between US forces and their counterparts in the Iraqi army and police at the joint coordination centre in Hawija. To make matters worse, rivalries between the Iraqi army and the country's (largely paramilitary) police force, over areas of responsibility and differing political allegiances, persisted.

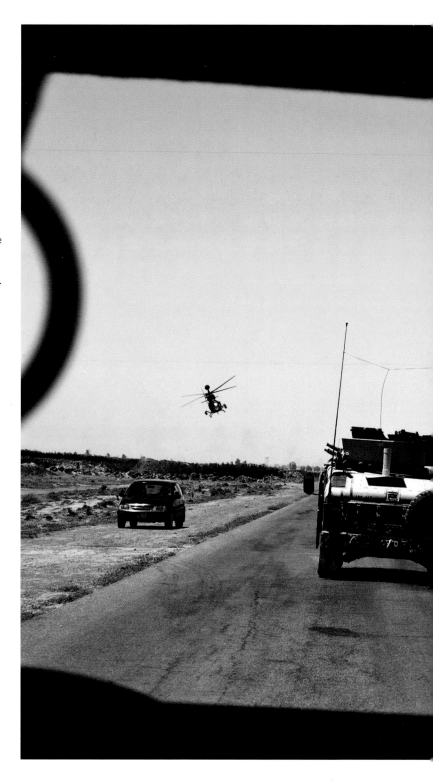

US patrol on the outskirts of Hawijah, 2006

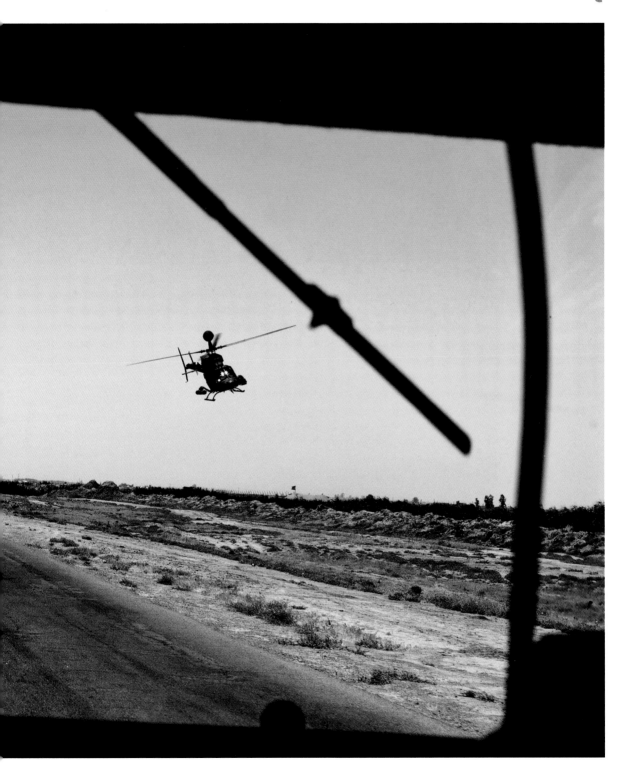

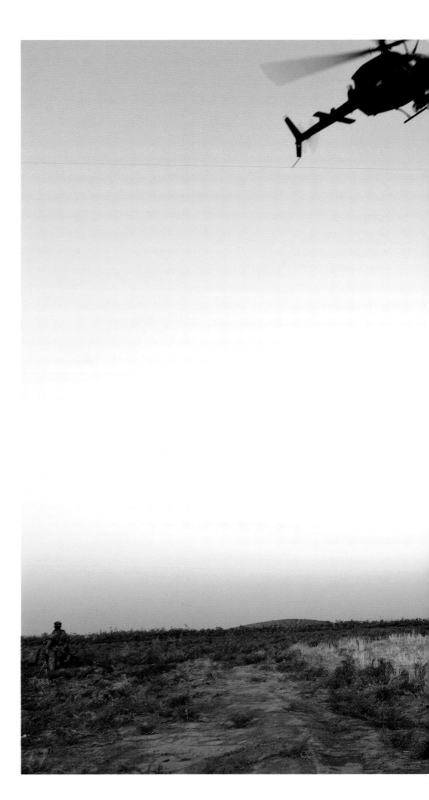

FRONTLINES | IRAQ

US and Iraqi army personnel carry out an early morning raid on farmhouses to arrest four wanted men. Three were captured and one escaped. West of Tikrit, 2006

US and Iraqi army personnel carry out an early morning raid on farmhouses to arrest four wanted men. Three were captured and one escaped. West of Tikrit, 2006

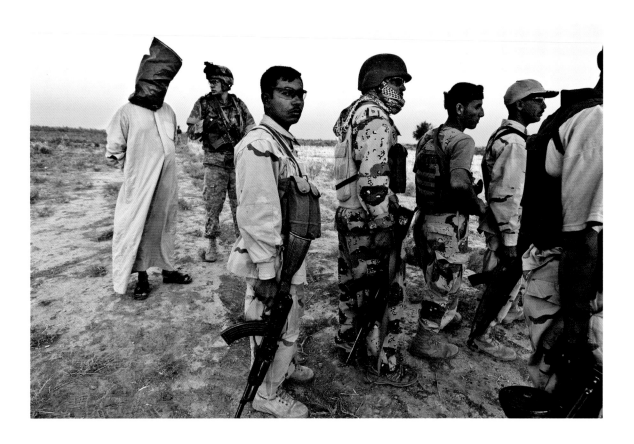

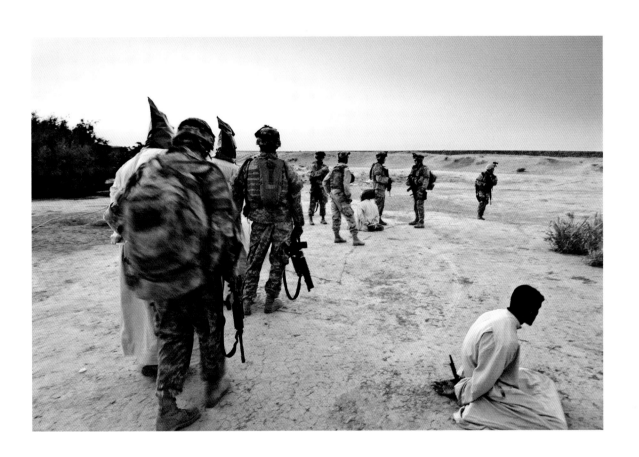

A group of men rounded up in Saddam Hussein's former parade ground (nicknamed The Birthday Palace) in Tikrit, 2006

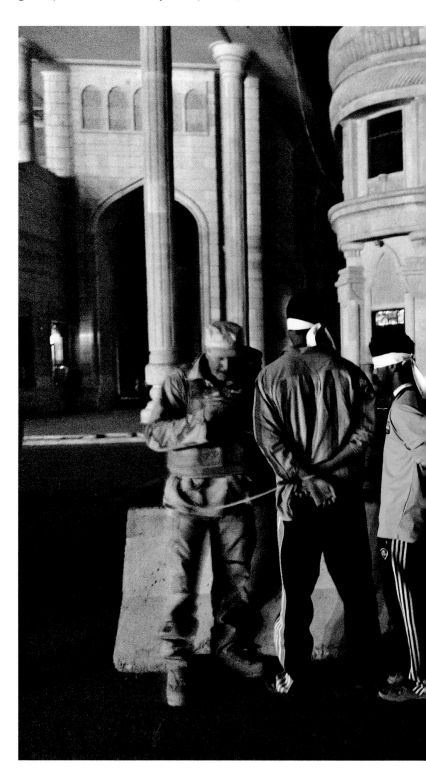

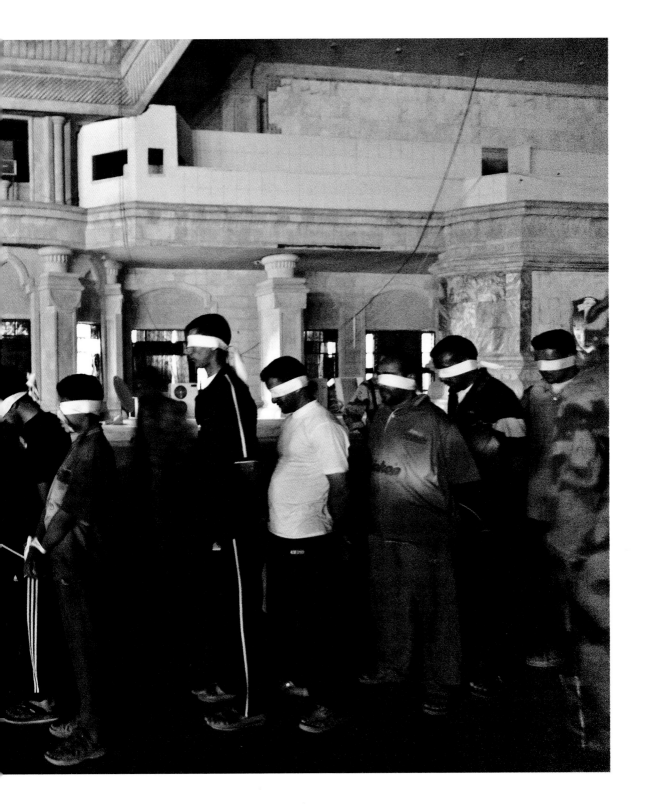

US soldiers convert part of the grandstand at The Birthday
Palace into a prison and temporary barracks, Tikrit, 2006

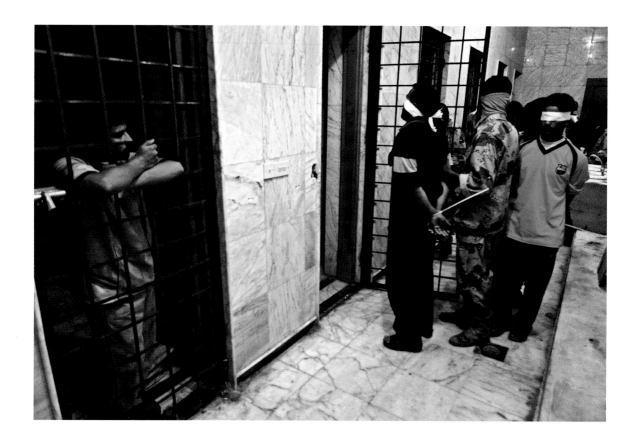

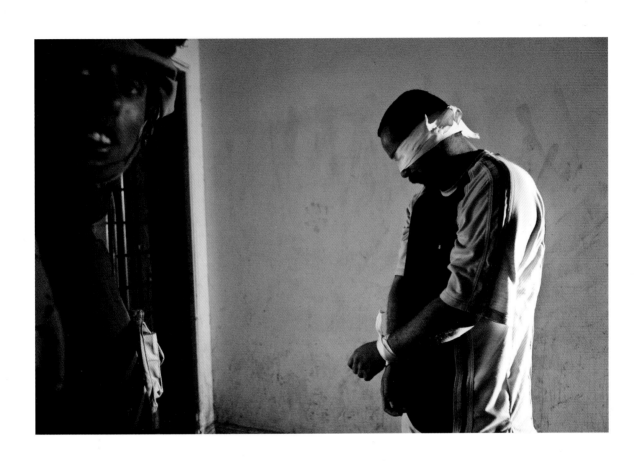

Iraqi soldier in the prison in
The Birthday Palace, Tikrit, 2006

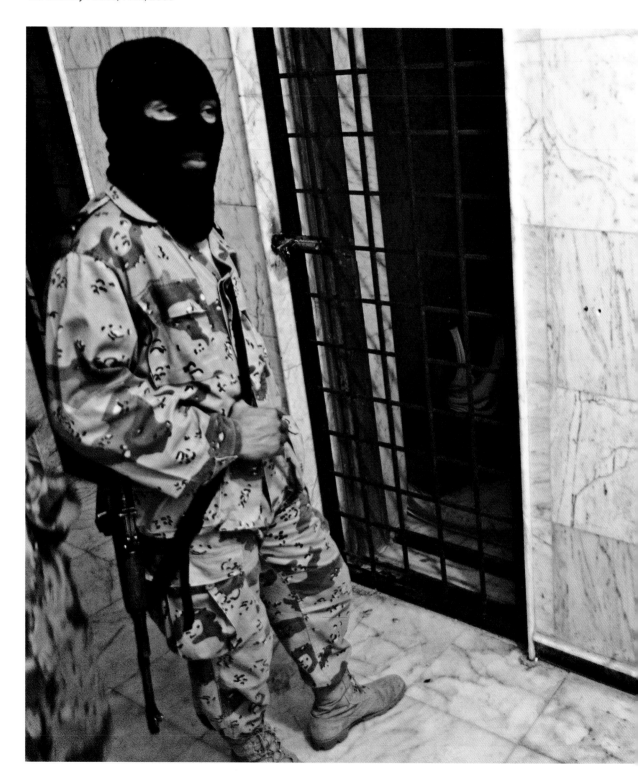

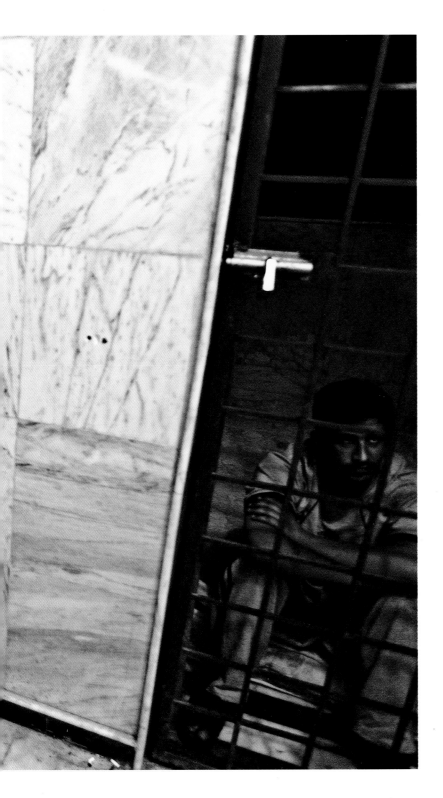

US army and Iraqi police intercept a group of
men who have planted an IED, Hawijah, 2006

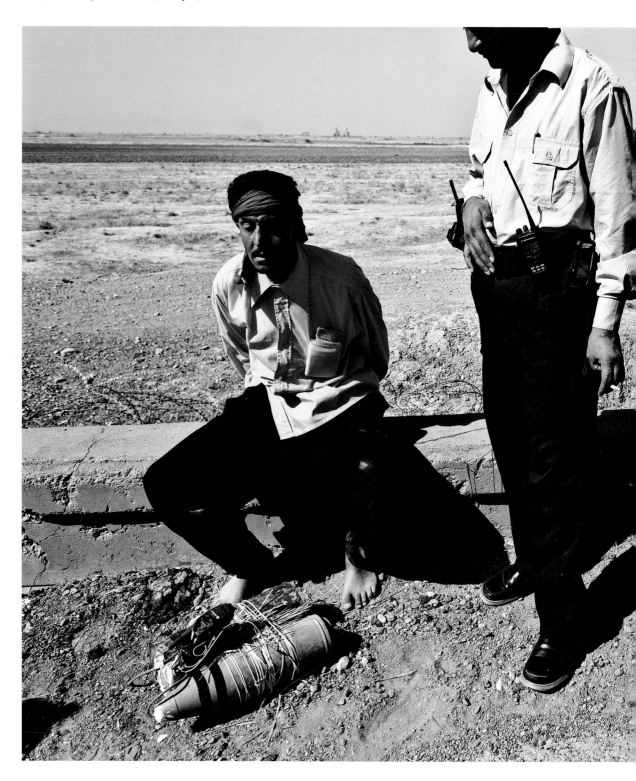

FRONTLINES | IRAQ

US army and Iraqi police intercept a group of
men who have planted an IED, Hawijah, 2006

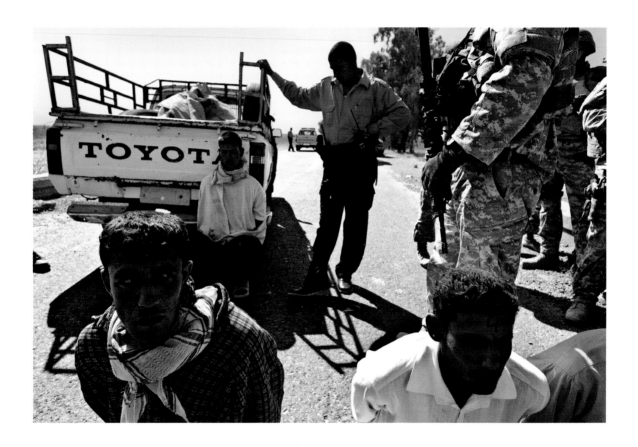

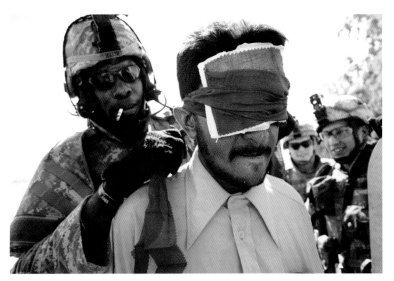

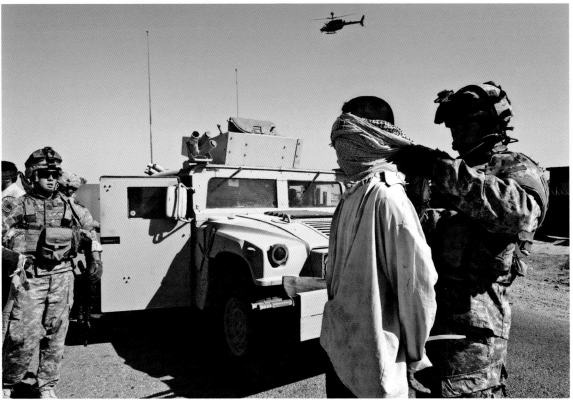

Iraqi soldiers are arrested after a home-made grenade
is thrown under a US Humvee as it enters the compound,
Joint Coordination Centre, Hawijah, 2006

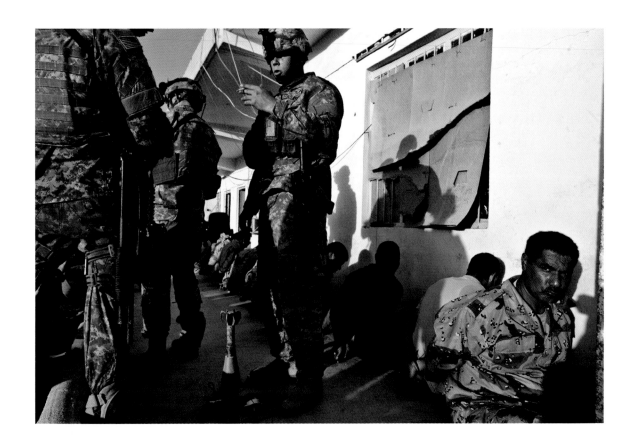

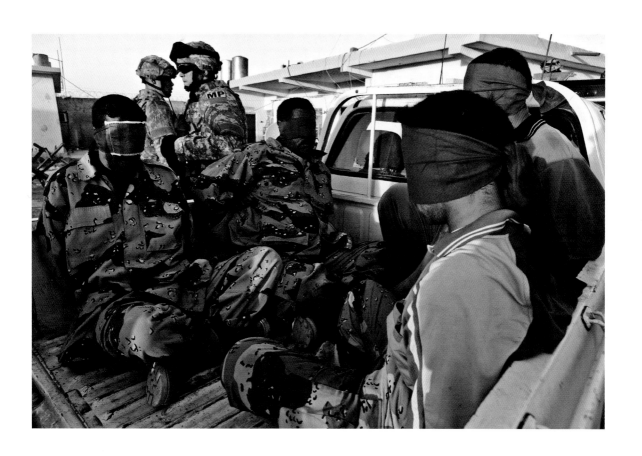

Iraqi police and local government officials in the Joint Coordination
Centre are arrested after a grenade is thrown from their offices
within the compound at the US forces, Hawijah, 2006

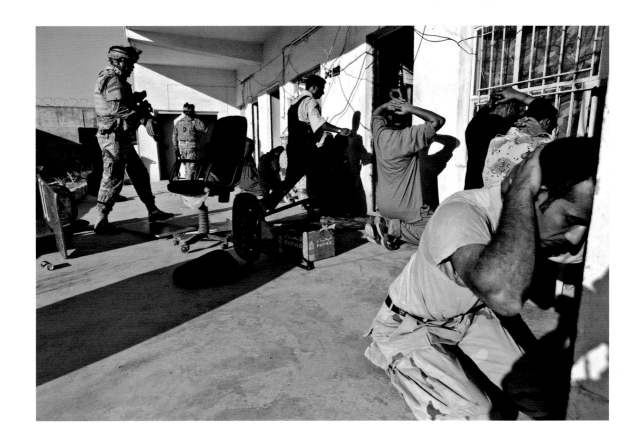

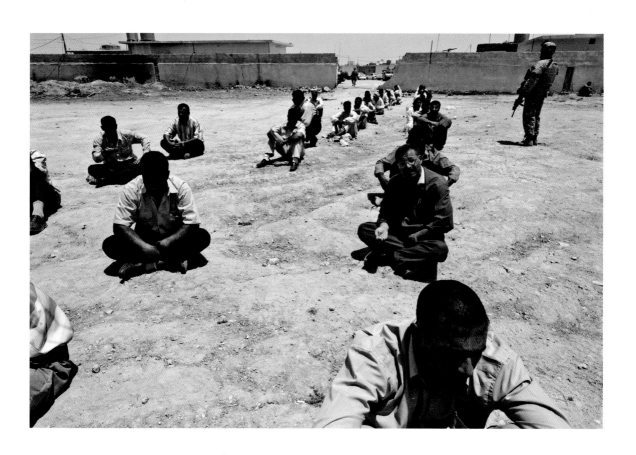

Soldiers from 101st Airborne Division,
Forward Operating Base, Renagen, Tikrit, 2006

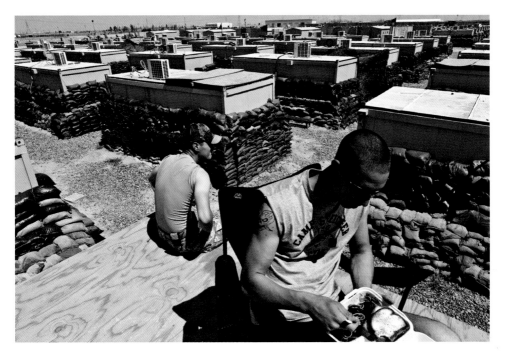

FRONTLINES | IRAQ

Patrol, Hawijah, 2006

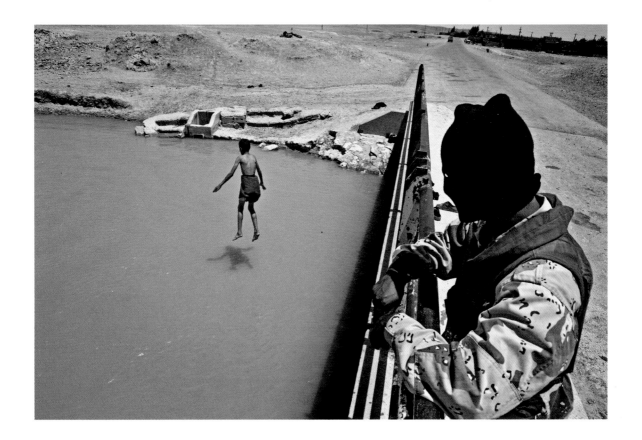

Iraqi police being drilled by US personnel
with translator, Tikrit, 2006

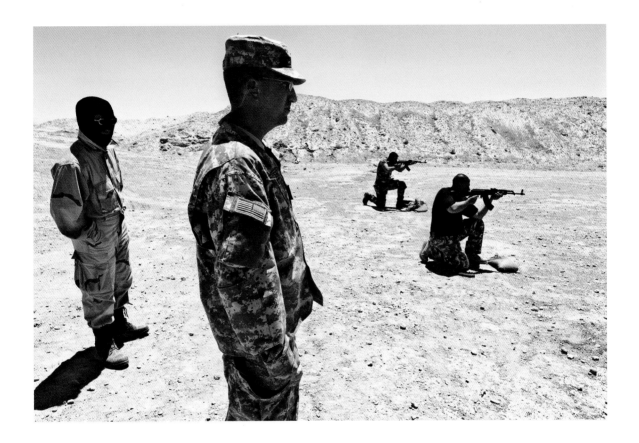

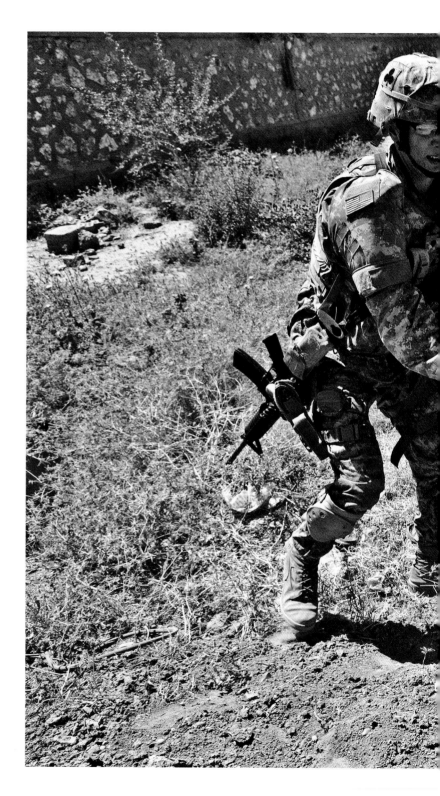

Soldiers from 101st Airborne Division capture a boy after the Iraqi police come under fire. The boy had been spotted with one of the suspected gunmen. Hawijah, 2006

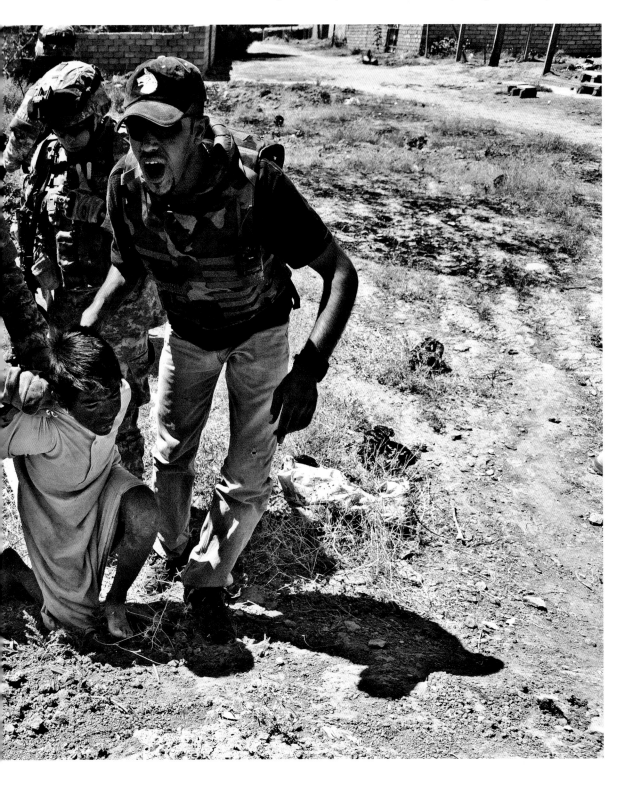

Man being stopped and questioned
by US and Iraqi soldiers, Tikrit, 2006

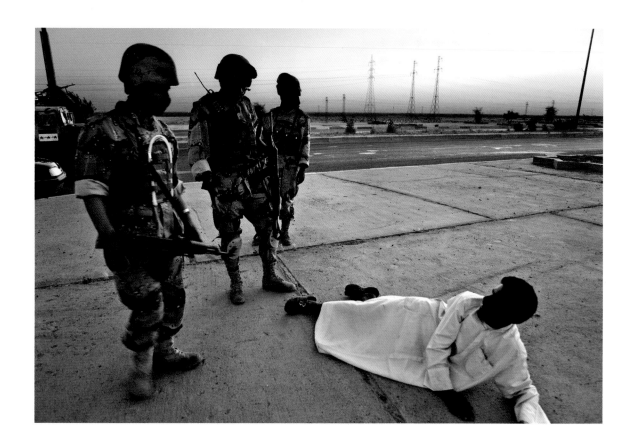

US soldiers, who had been under attack, treat a man who they have just shot when his car failed to stop quickly enough, Hawijah, 2006

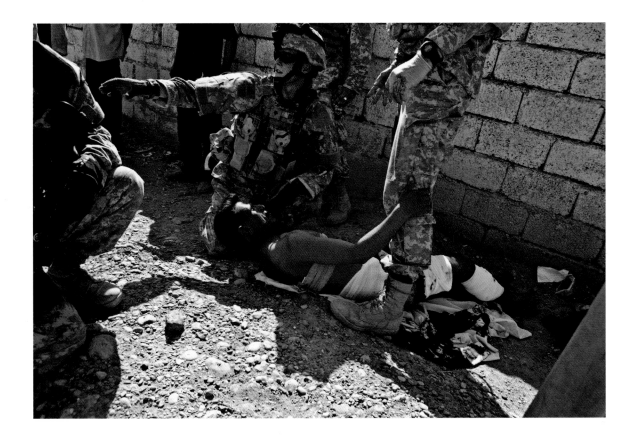

Two boys injured by an IED whose target
was a US vehicle control, Hawijah, 2006

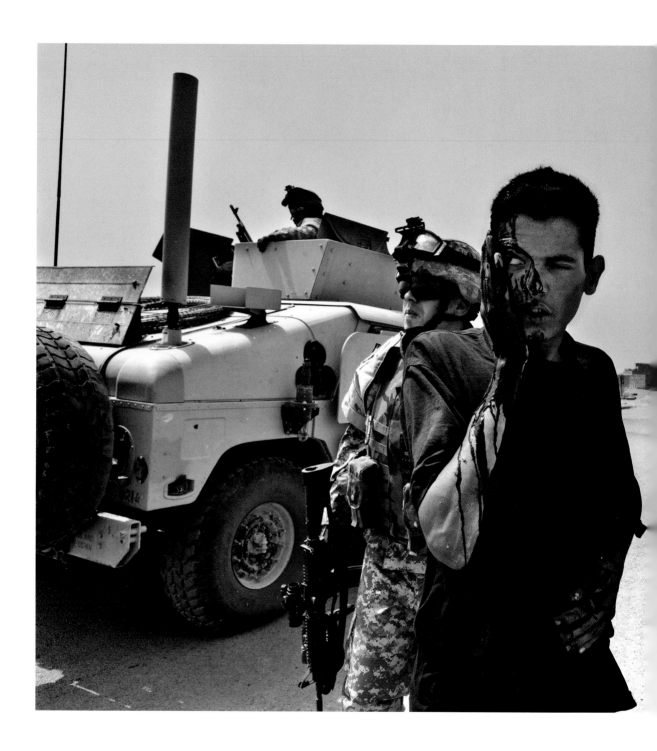

FRONTLINES | IRAQ

CONGO

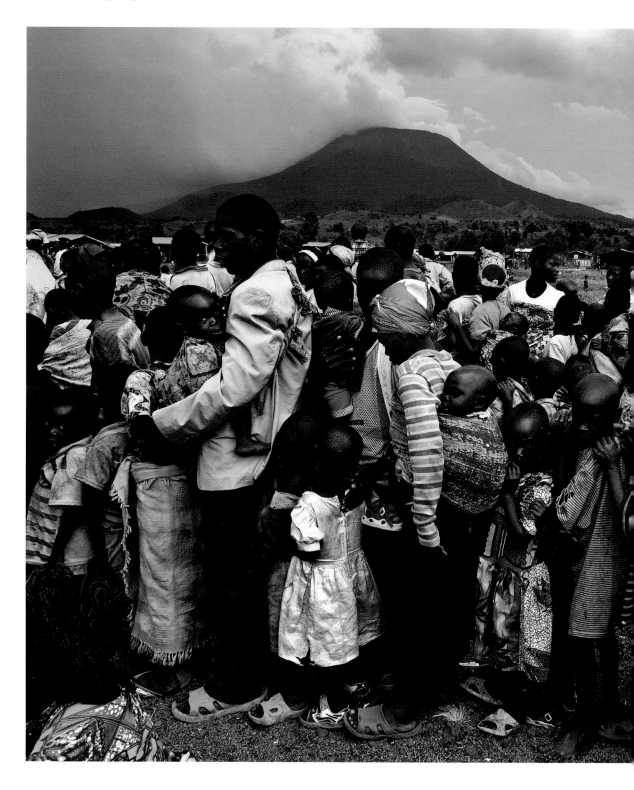

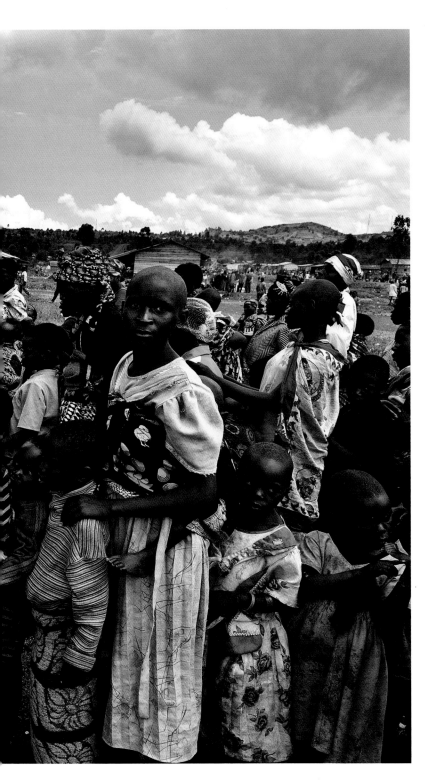

In the aftermath of the 1994 genocide in Rwanda, more than one million Hutu refugees fled across the border to Zaire – now called the Democratic Republic of Congo – driven by the fear among many of their politicians, soldiers and militias that the population would be killed by the new Tutsi-led government. Hutu extremists used the cover of UN-run refugee camps to launch raids into Rwanda, against the new administration, and to attack Zaire's sizeable Tutsi population.

In 1996, Rwanda responded by invading Zaire in order to attack the armed Hutu forces and drive the refugees home. The following year, the invasion went on to overthrow Zaire's leader, Mobutu Sese Seko, but this did not put an end to the conflict, which dragged on for several more years.

In late 2008, Rwanda was accused of backing the Tutsi rebel leader Laurent Nkunda, who attacked several towns and threatened the provincial capital of the eastern Democratic Republic of Congo, Goma – displacing about 250,000 people. Hutu militias continue to threaten Rwanda. Increasingly, the conflict becomes one about control over lucrative mining deposits in eastern Congo – diamonds, gold and a large concentration of coltan, a valuable component used in mobile phones.

Food distribution queue at a displaced persons camp in Kibati, north of Goma, 2008

Rebel soldiers loyal to the Tutsi General Laurent Nkunda,
in the town of Rugare, north of Goma, 2008

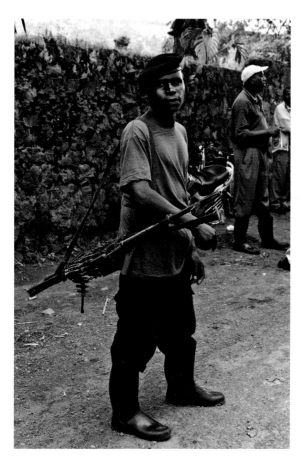 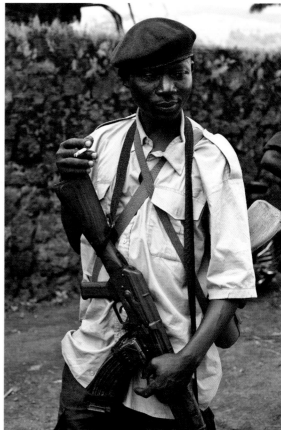

FRONTLINES | CONGO

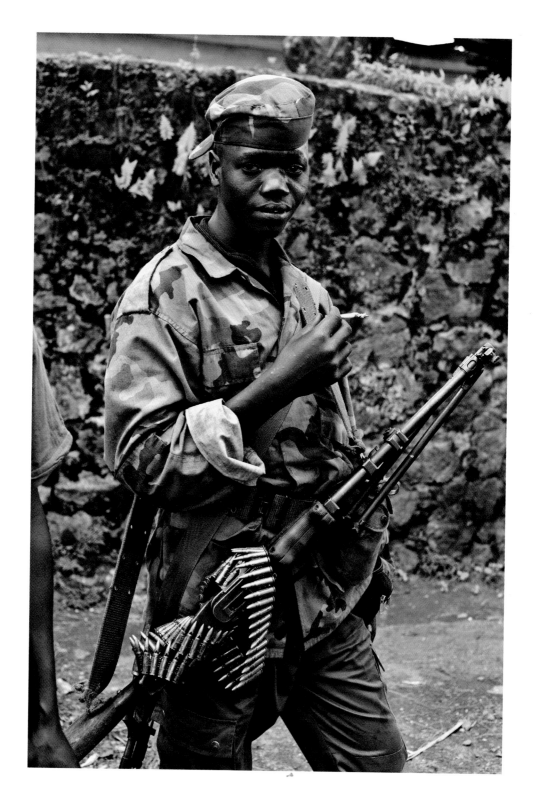

FRONTLINES | CONGO

A government soldier talks to displaced
people in the Kibati camp, 2008

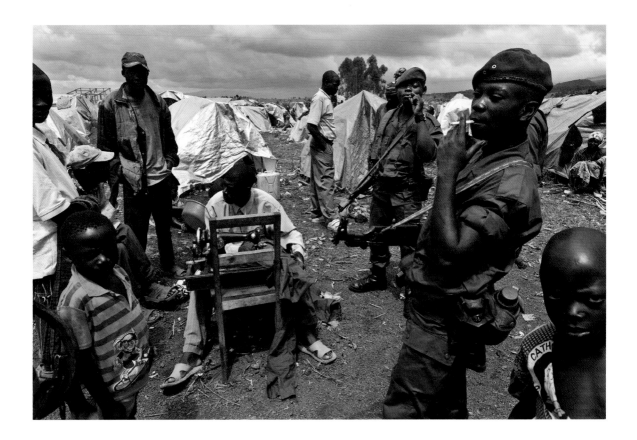

A government soldier heads toward the fighting. The day
before, the area had been in rebel hands. Kibati, 2008

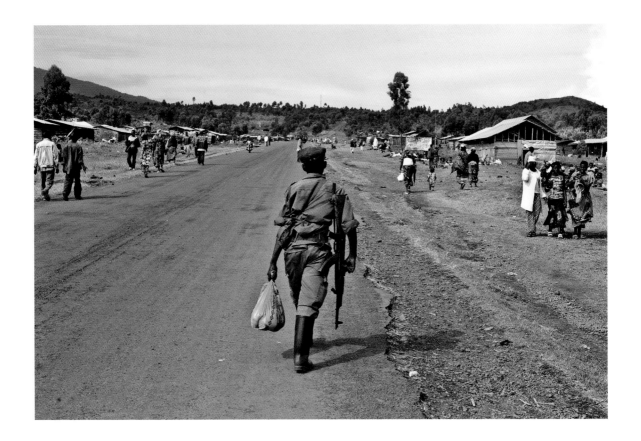

A mother mourns her dead son, shot by rebels
in the village of Kiwanja, north of Rutshuru, 2008

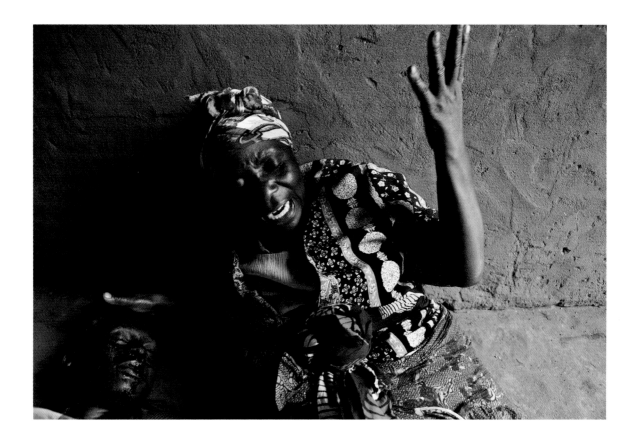

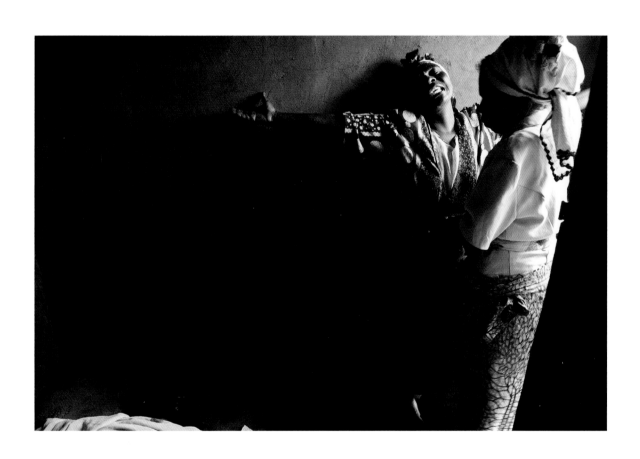

UN Mission (MONUC), on
the road to Rugare, 2008

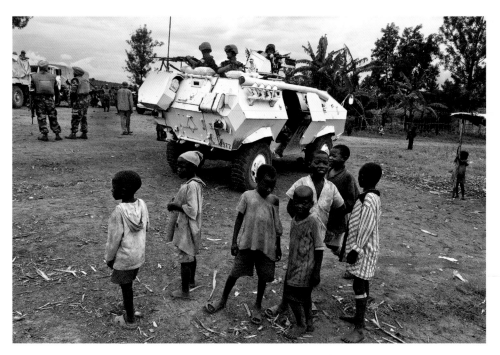

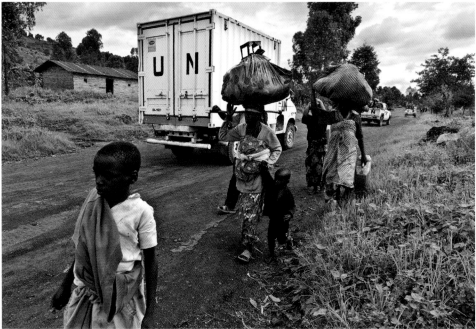

Guatemalan soldiers from the UN Mission
(MONUC) patrol a road in Kibati, 2008

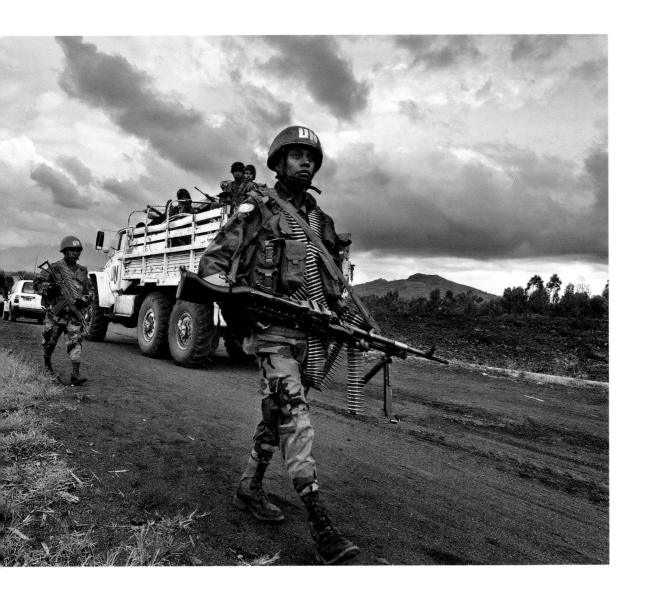

Government soldiers carry weapons near the front of the fighting. The area
had been in rebel hands the day before. Outskirts of Kibati, 2008

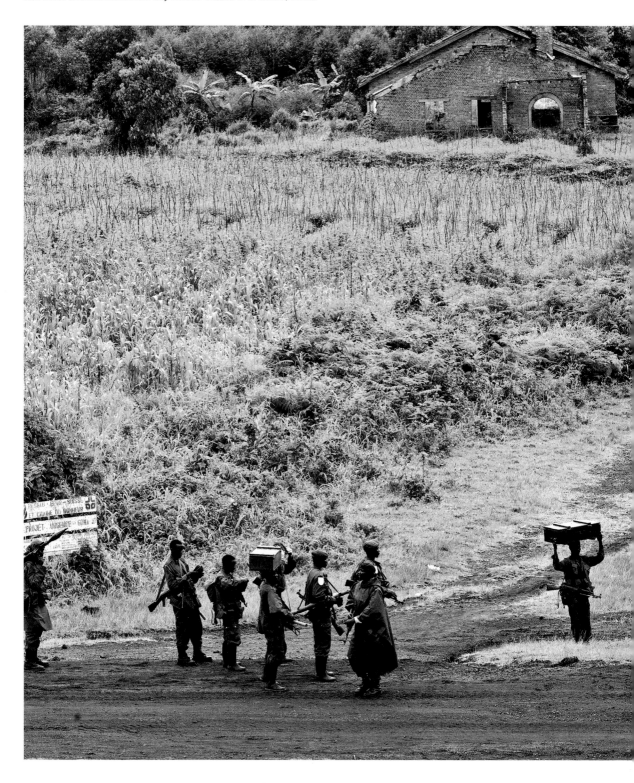

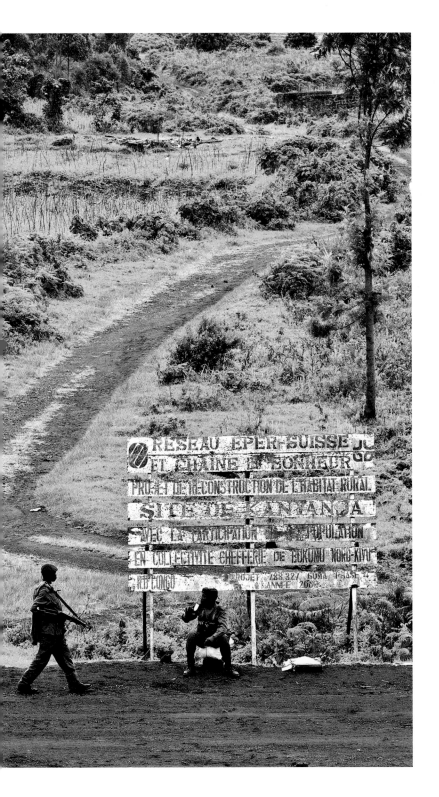

Returning villagers discover the body of a victim allegedly shot
by rebel soldiers loyal to Laurent Nkunda, Kiwanja, 2008

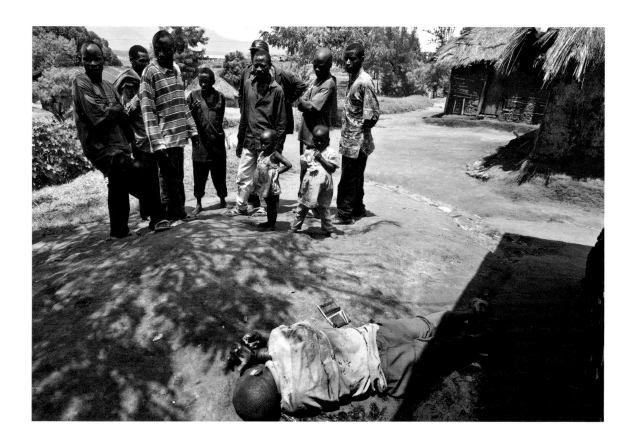

UN monitors (MONUC) searching for victims of
the fighting in the village of Kiwanja, 2008

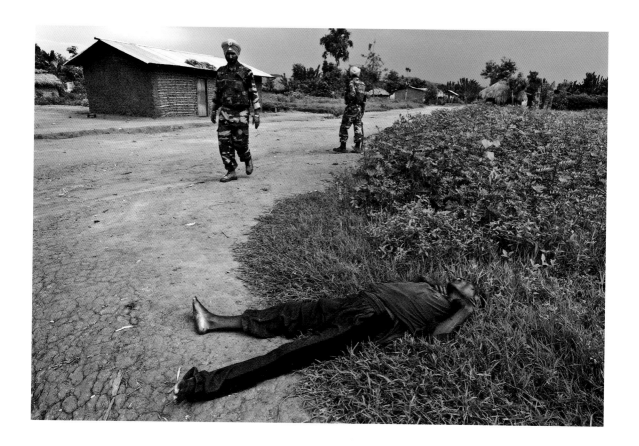

In the village of Kiwanja, rebel soldiers killed anyone suspected of
government support, either as a soldier or civilian, Kiwanja, 2008

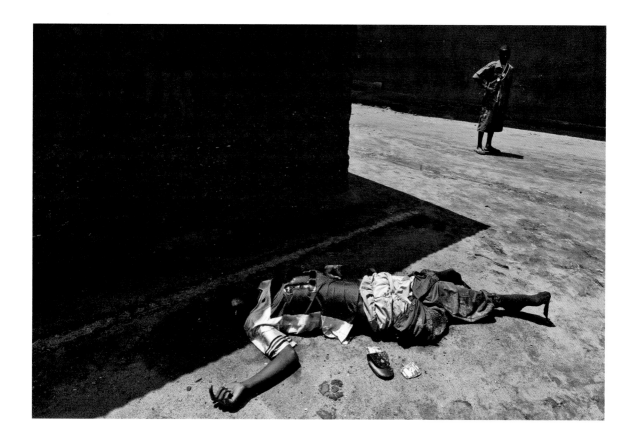

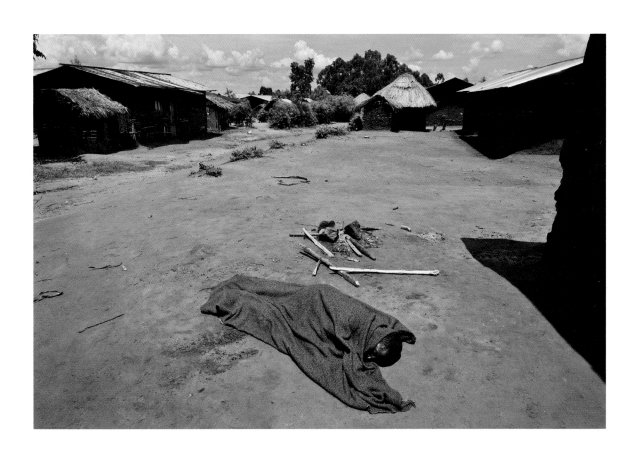

Government soldiers just outside
Kibati, 2008

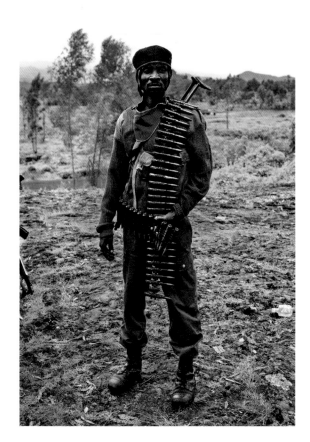

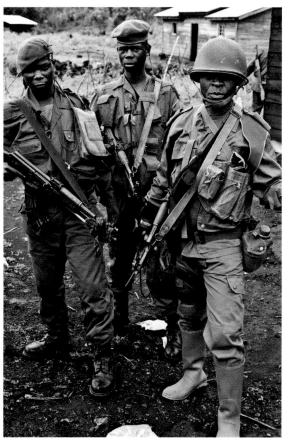

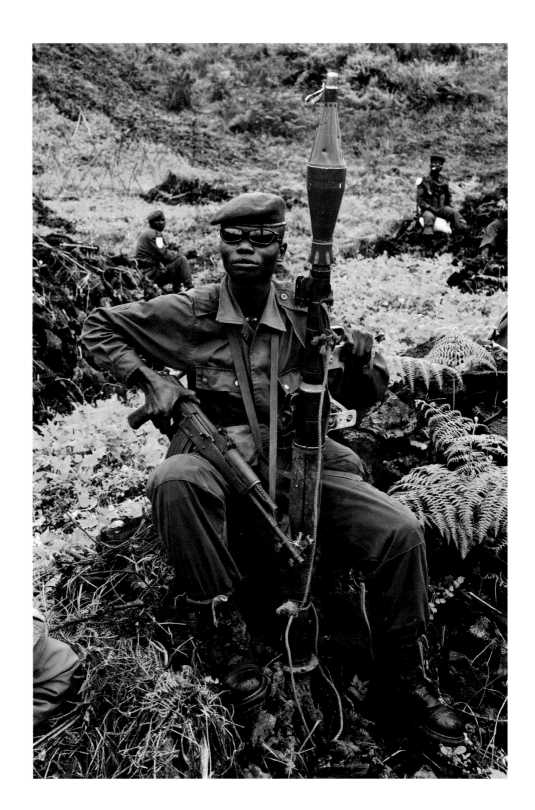

Government soldiers drag armaments to the top
of a hill near the front outside Kibati, 2008

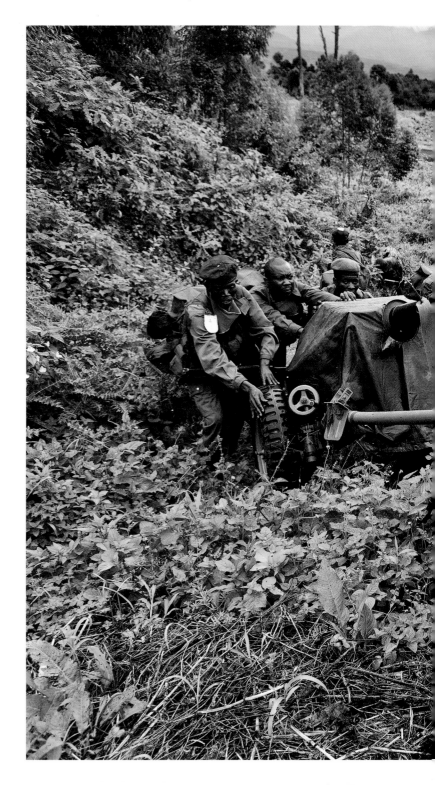

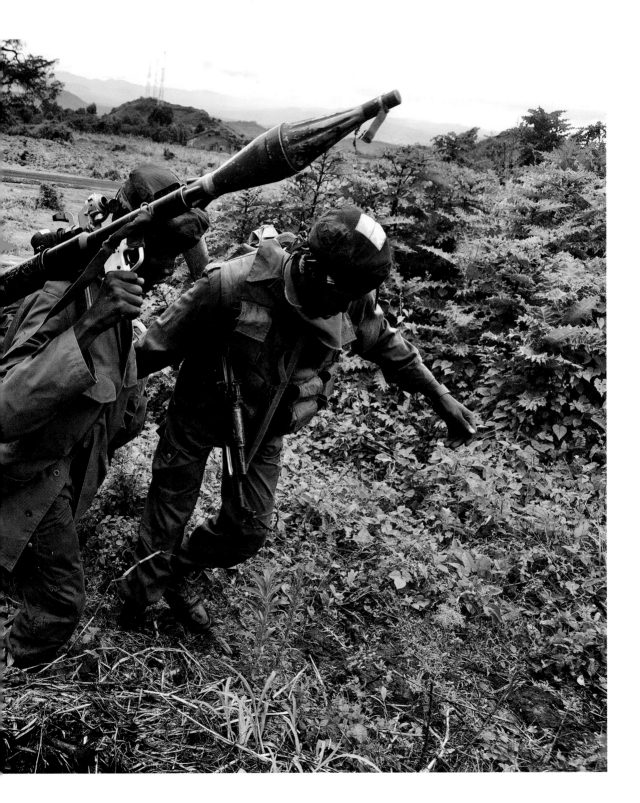

Government soldiers,
outskirts of Kibati, 2008

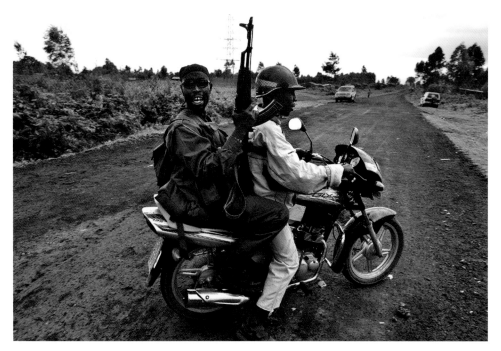

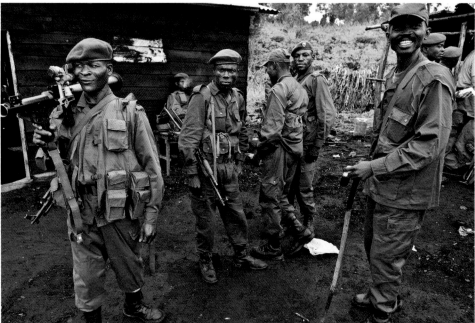

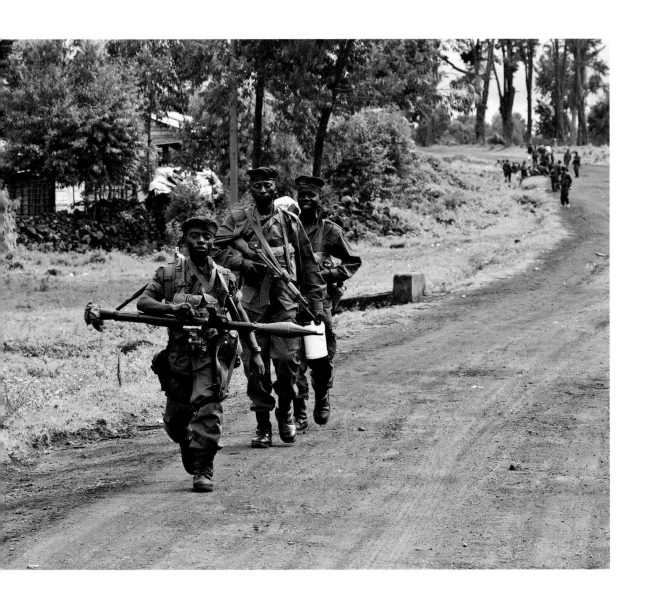

Chickens scavenge a dead body
in Kiwanja, 2008

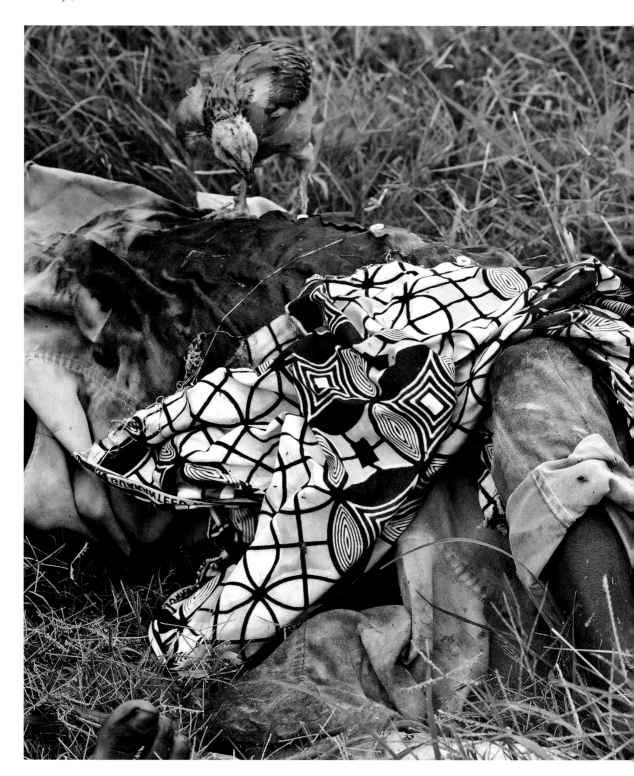

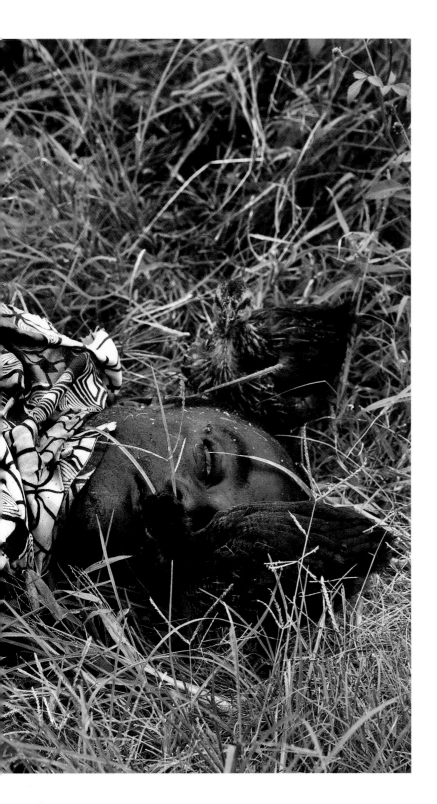

Red Cross workers record and bury victims of the fighting
on the road between Goma and Rutshuru, 2008

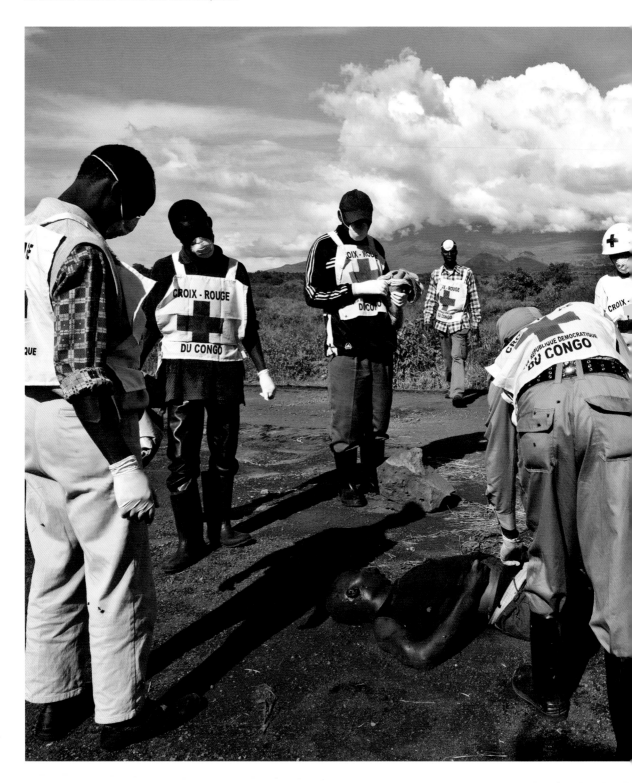

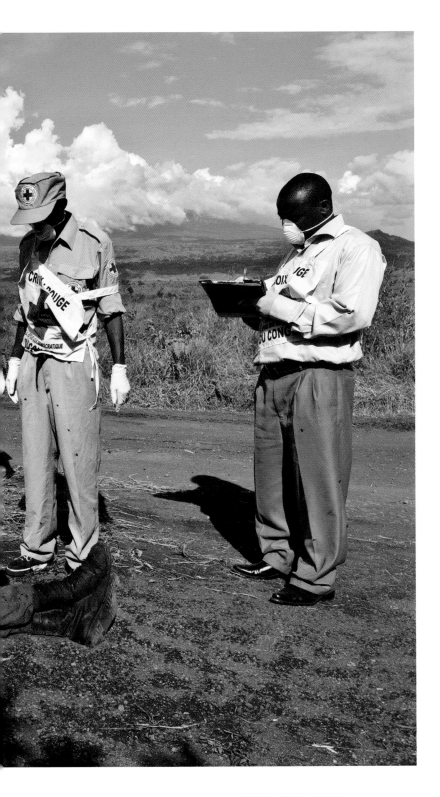

As the fighting gets closer, residents of Kiwanja flee
to the town of Rutshuru in eastern Congo, 2008

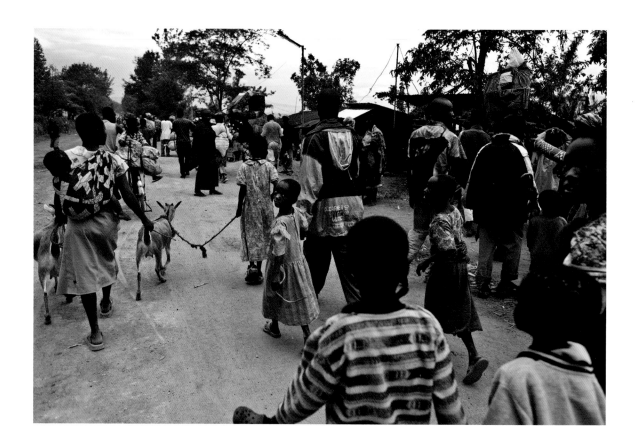

Displaced persons camp, Kibati, 2008

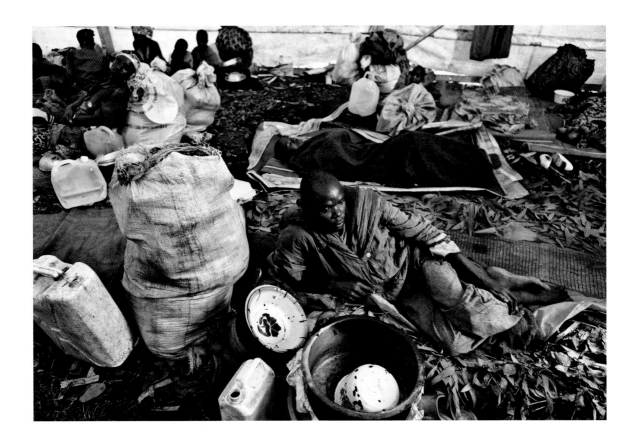

The body of a victim outside Kibati, 2008

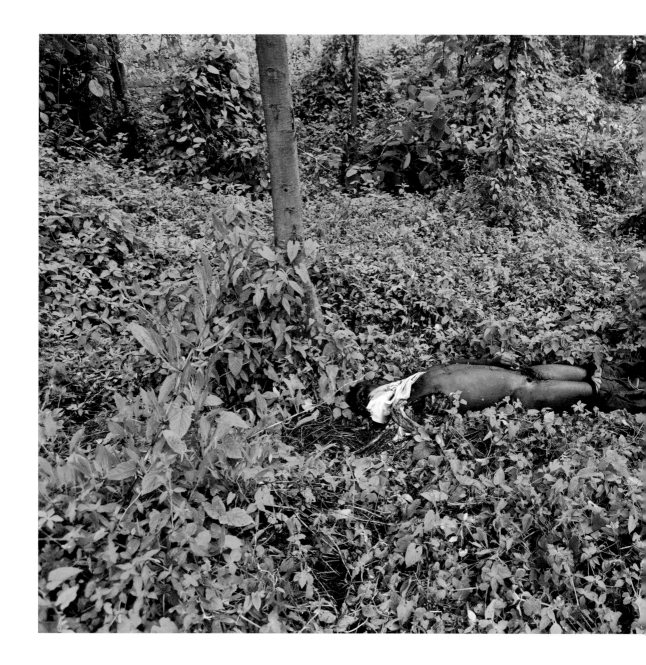

IRAQ

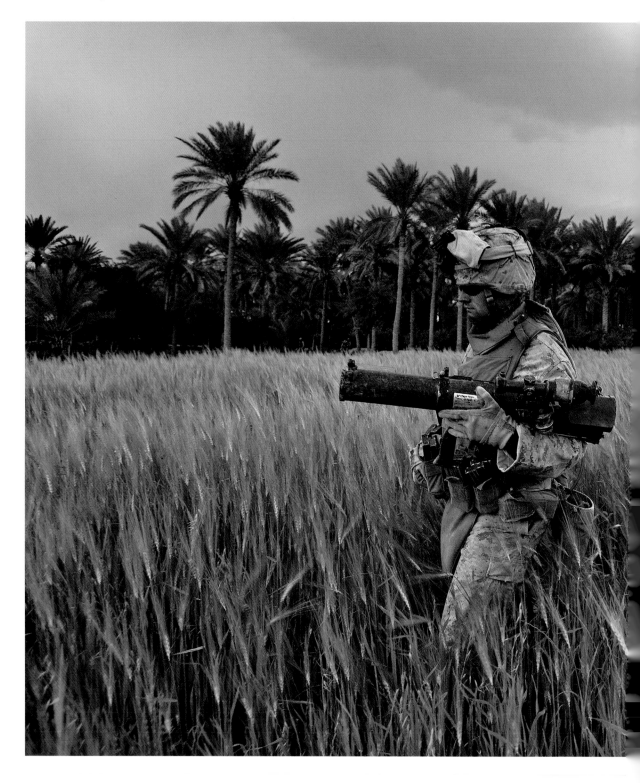

In January 2007, President Bush announced a 'surge' of 20,000 additional troops to provide security in Al Anbar province and Baghdad, but the surge had little immediate impact on the high levels of violence and suicide bombings. Militias known as the 'Awakening' movement, drawn largely from Sunni tribes, were armed and paid for by the US to fight extremists at a local level. This new strategy was credited with reducing insurgent incidents in Al Anbar and it was replicated in other parts of the country. However, there was often an uneasy relationship between these groups and US forces.

In March 2009, US forces and the Iraqi army carried out a major offensive against the Shia Madhi army office in north Baghdad. In late May, a deal between the Iraqi government and the Madhi army resulted in an unofficial ceasefire.

US Marines carrying out a sweep for weapons and insurgents in Al Anbar province, 2007

US Marine, Al Hywatt Combat Outpost,
Al Anbar province, 2007

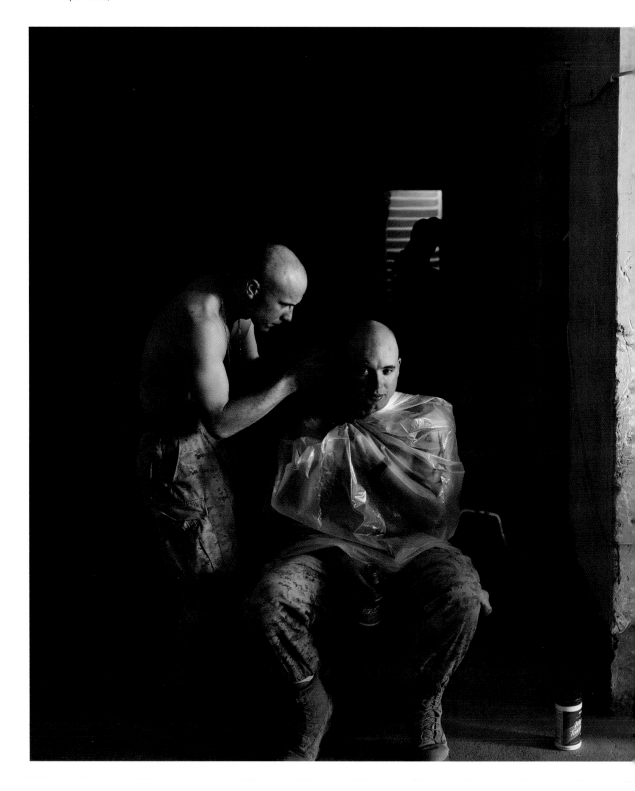

During a sweep along the banks of the Euphrates, US Marines
discover a small arms cache, Al Hwyatt, 2007

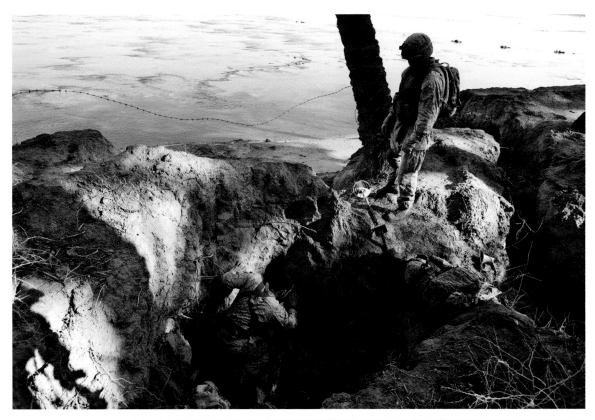

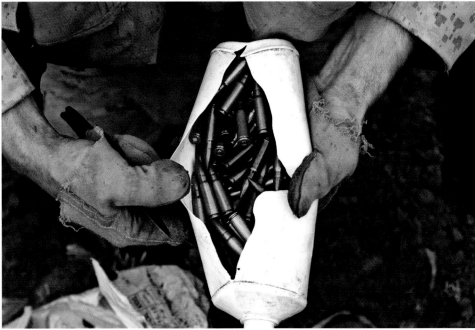

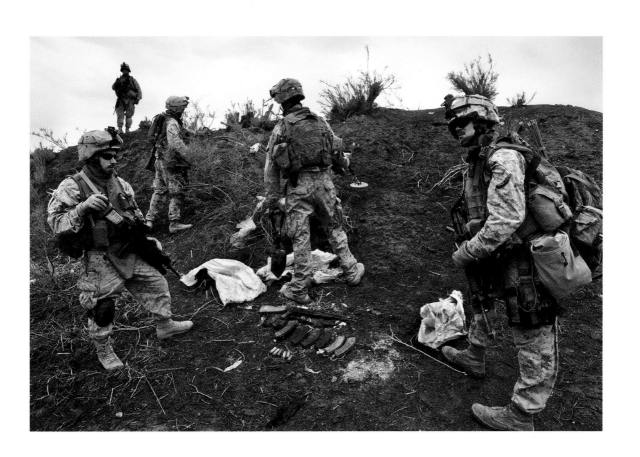

FRONTLINES | IRAQ

Exhausted US Marines resting during
a sweep of Al Hywatt, 2007

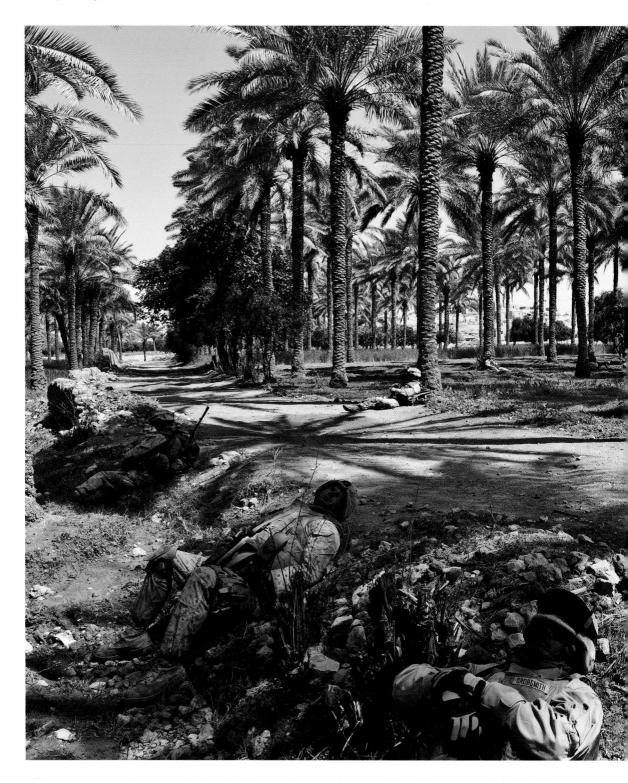

US soldiers from the 2nd Stryker respond to an IED attack on
a Bradley which has killed six US soldiers and a translator in
Al Amiriya, a Sunni neighbourhood of west Baghdad, 2007

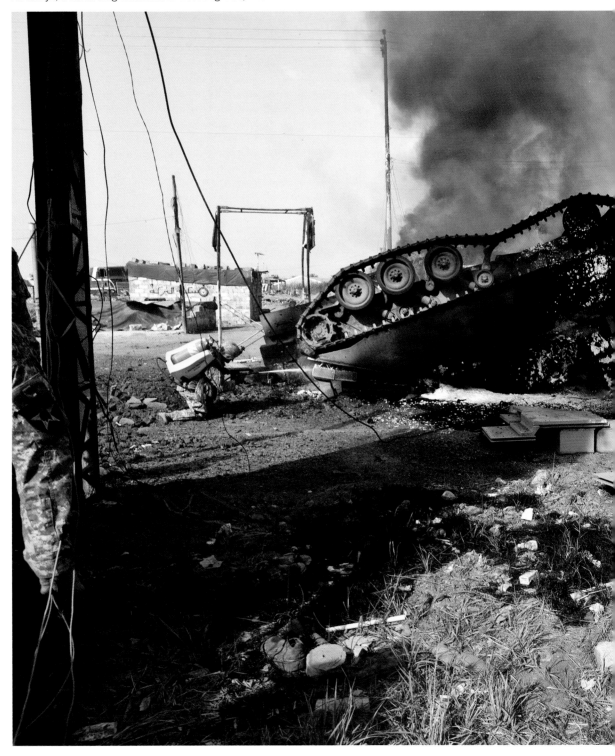

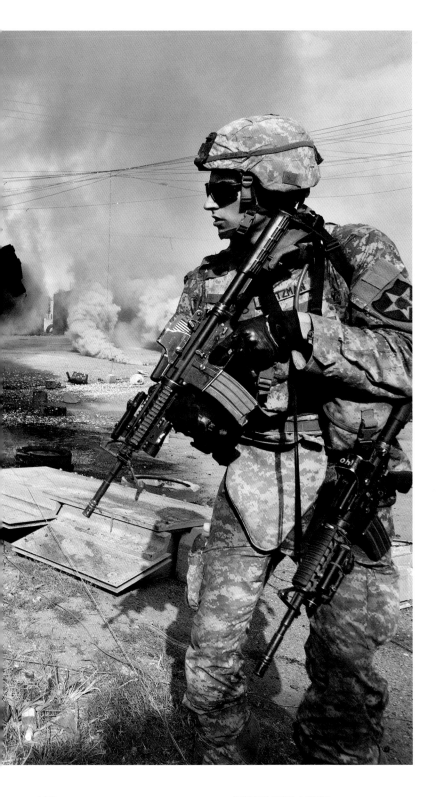

FRONTLINES | IRAQ

US soldiers shoot a man who refused to stop during house-to-house searches in west Baghdad, 2007

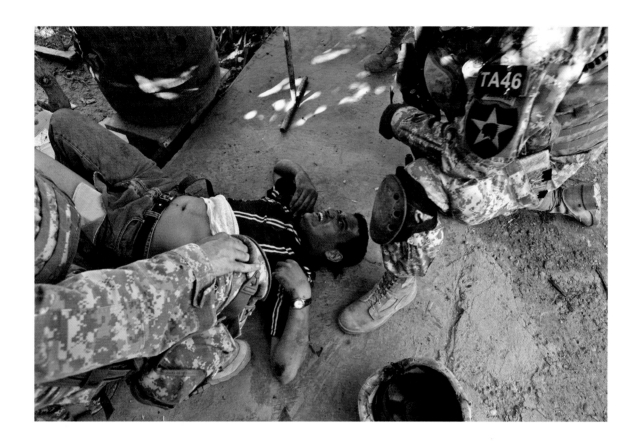

Man shot dead by US soldiers when he failed to stop his car. The soldiers suspected him of involvement in an imminent attack. However, it seems he was a taxi driver who had merely got lost in the area because of the numerous road closures. West Baghdad, 2007

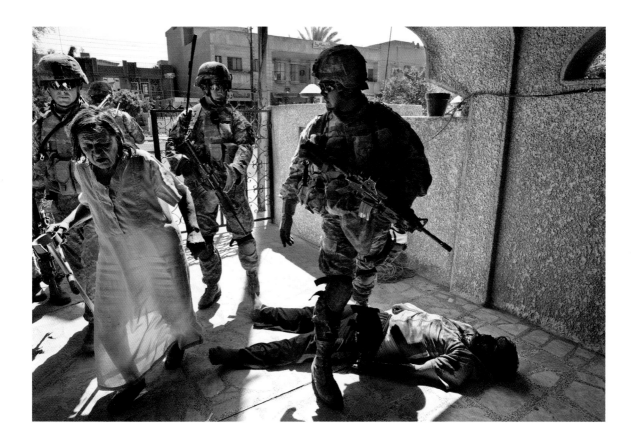

US soldiers conducting house-to-house searches in a Sunni neighbourhood in west Baghdad, allegedly controlled by Al Qaida, Al Amiriya, 2007

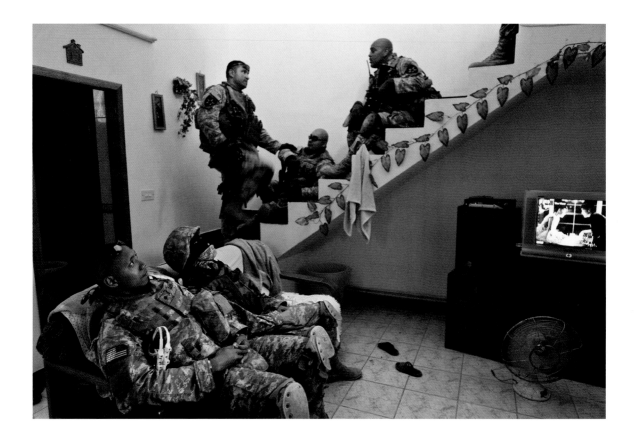

US soldiers involved in mentoring at an Iraqi army post, Al Amiriya, 2007 (*below*)

US soldier keeps watch during house-to-house searches, Al Amiriya, 2007 (*bottom*)

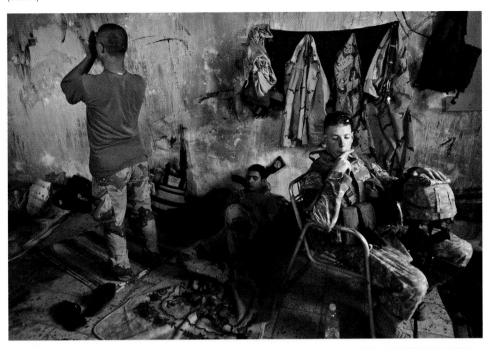

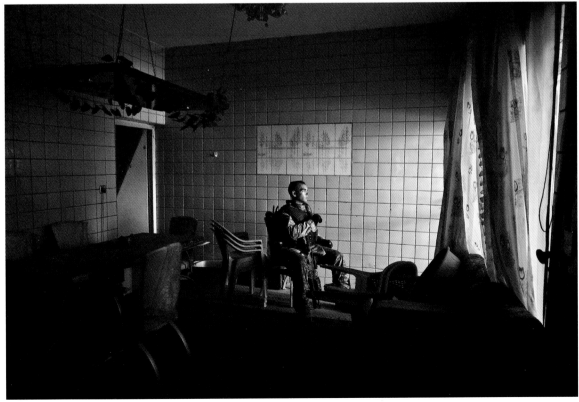

After coming under sniper attack, US soldiers raid the house from which the fire was coming. By the time they are able to occupy the house, the snipers have fled and the residents are interrogated. Al Amiriya, 2007

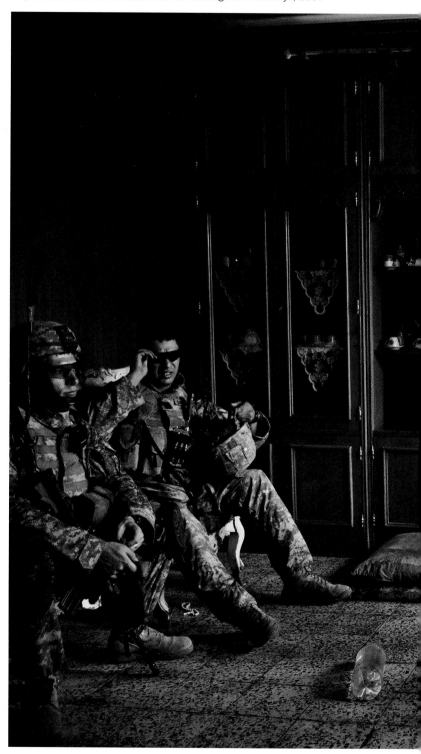

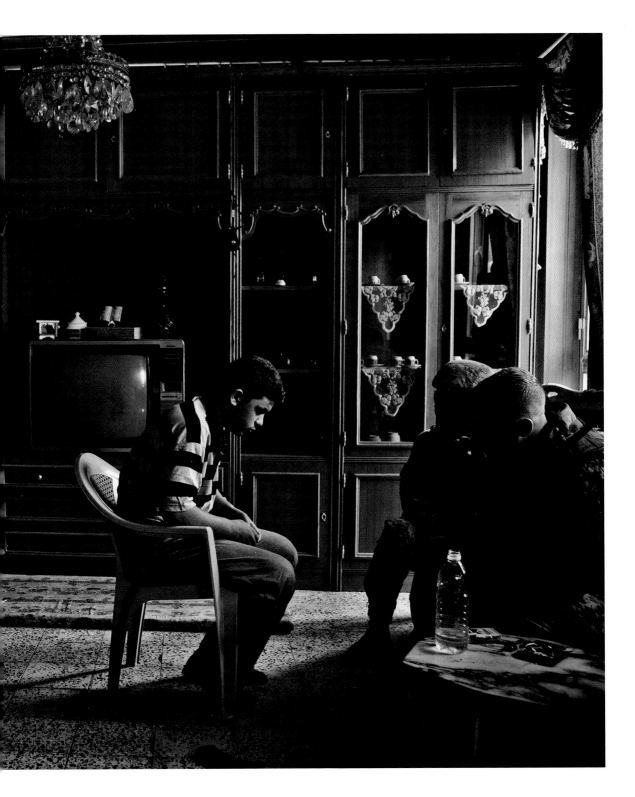

A teenager, who is alleged to be a member of Al Qaida, is handed over
to US forces by Iraqi militias now working alongside them, Al Amiriya, 2007

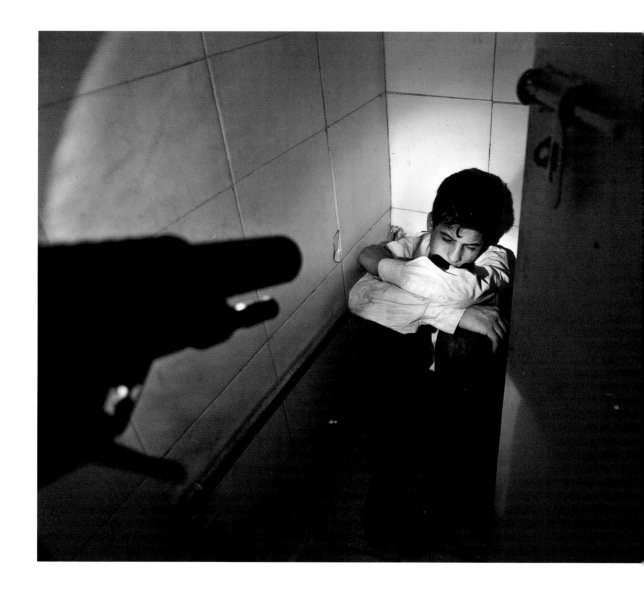

Anti-Al Qaida, Sunni militias form an uneasy alliance with US forces. In an effort to identify themselves, these armed militias wear white headbands to avoid being shot by their allies. Al Amiriya, 2007

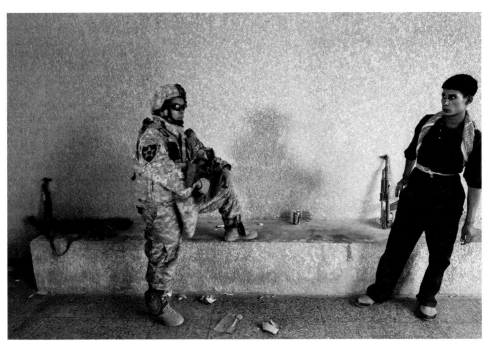

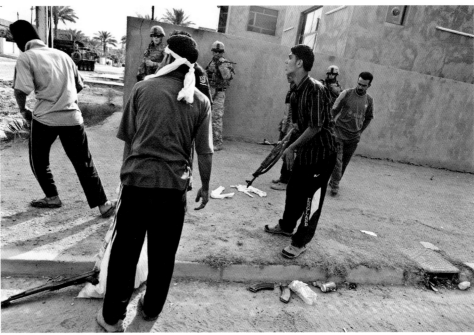

US and Iraqi soldiers, called to the scene of an explosion, discover a bomb factory spread over several buildings. One man was killed, apparently while assembling a bomb. A secondary explosion happened during the search, injuring several local residents and Iraqi soldiers, one seriously. West Baghdad, 2007

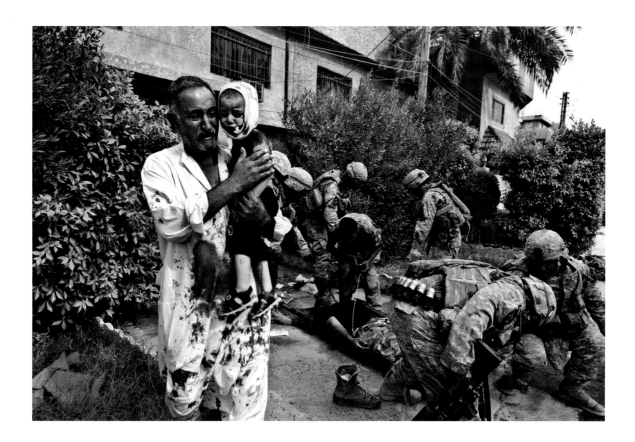

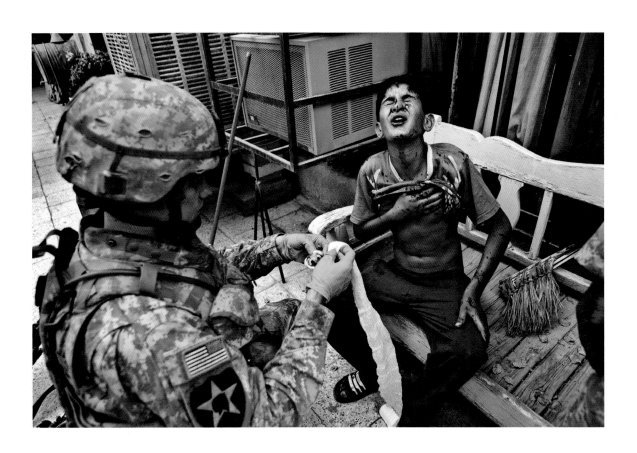

Iraqi soldier injured by an explosion at
bomb factory, west Baghdad, 2007

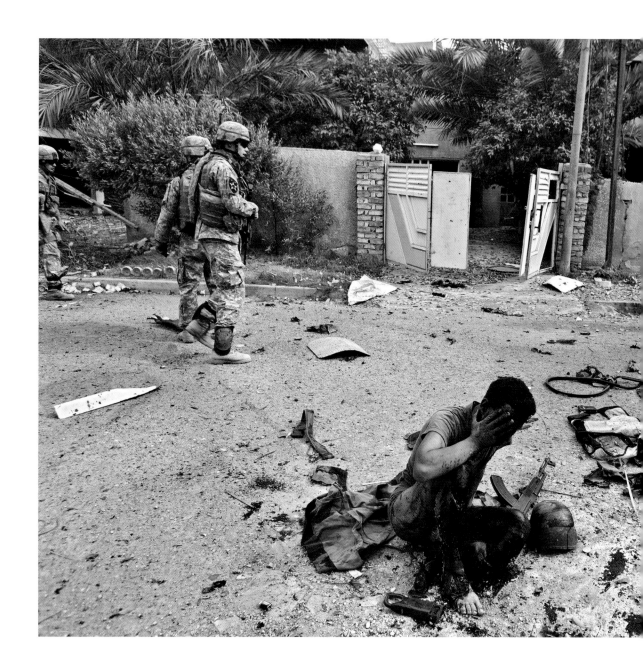

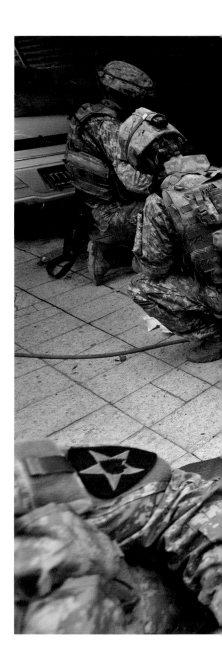

US soldiers attend to Iraqi civilians injured by an
explosion at a bomb factory, west Baghdad, 2007

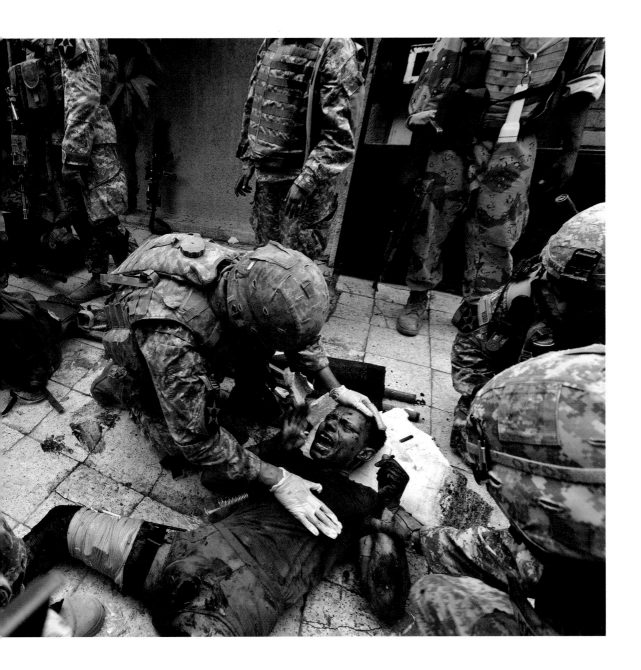

US soldiers attend to Iraqi civilians injured by an
explosion at a bomb factory, west Baghdad, 2007

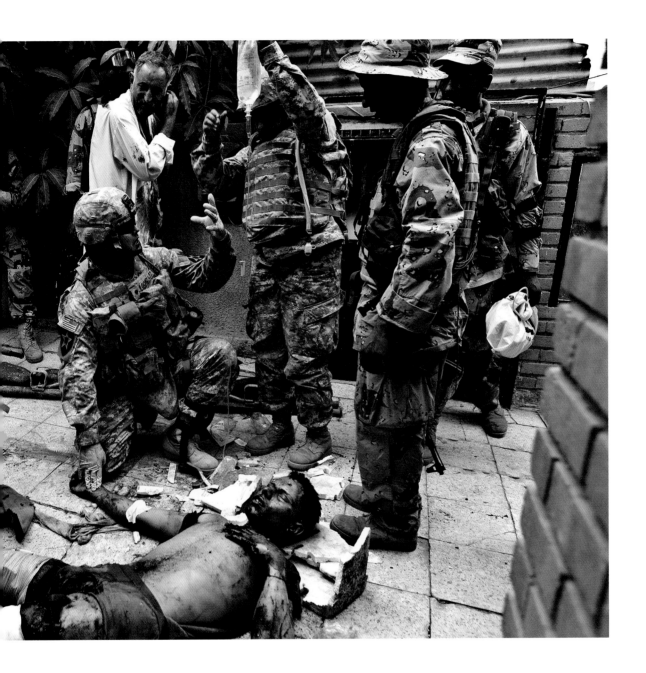

FRONTLINES | IRAQ

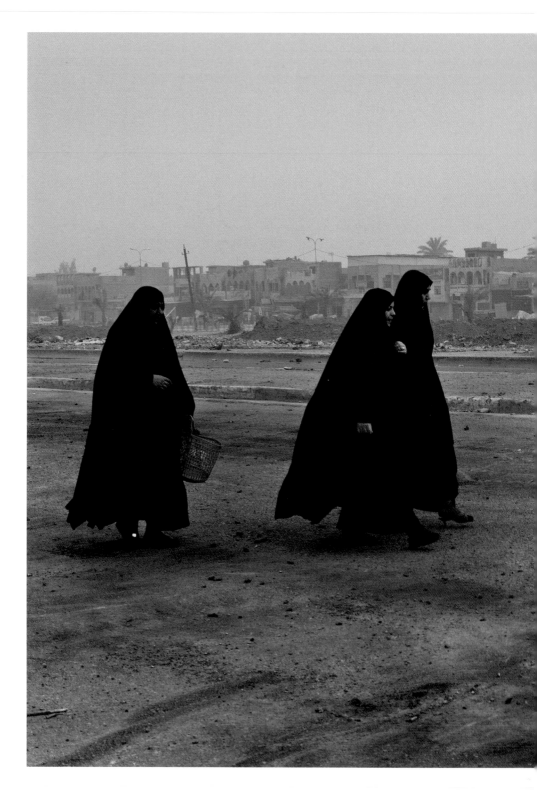

During an early morning lull in fighting between the Mahdi Army and 101st Airborne Division and Iraqi army, local women venture out, north west Baghdad, 2008

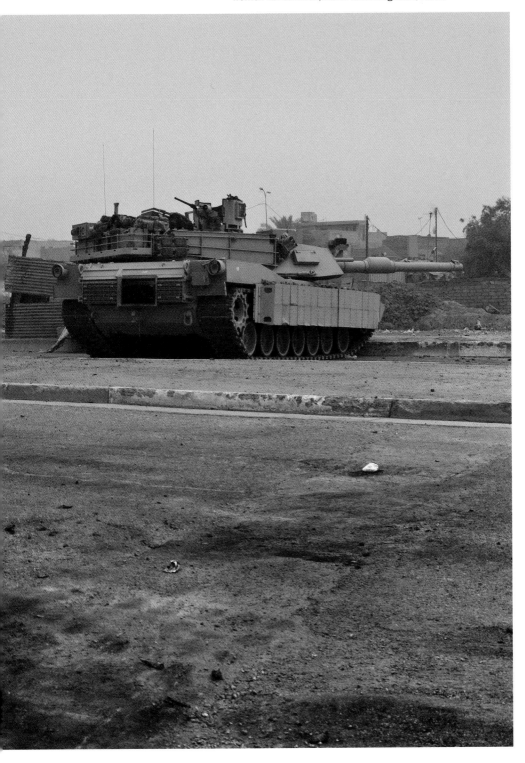

FRONTLINES | IRAQ

US soldiers come under fire after taking control of
the Mahdi Army offices, north west Baghdad, 2008

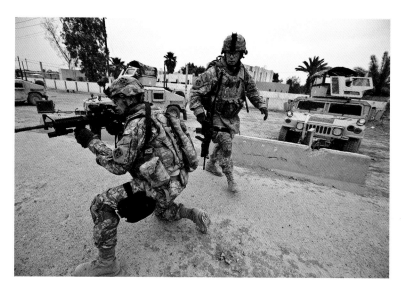

US soldiers put men on the roof of the Mahdi Army
offices to return hostile fire, north west Baghdad, 2008

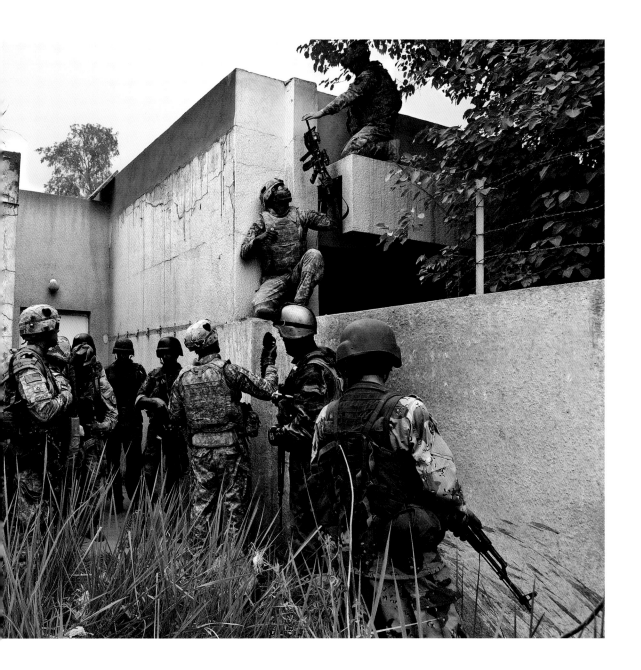

FRONTLINES | IRAQ

US soldiers from 101st Airborne Division and Iraqi soldiers
question a man during a night raid, north west Baghdad, 2008

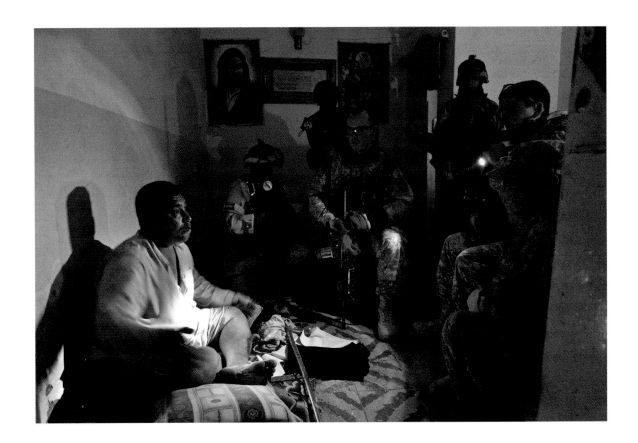

FRONTLINES | IRAQ

US soldiers arrest a young man whose name appeared
on a list of suspects, Shula area of Baghdad, 2008

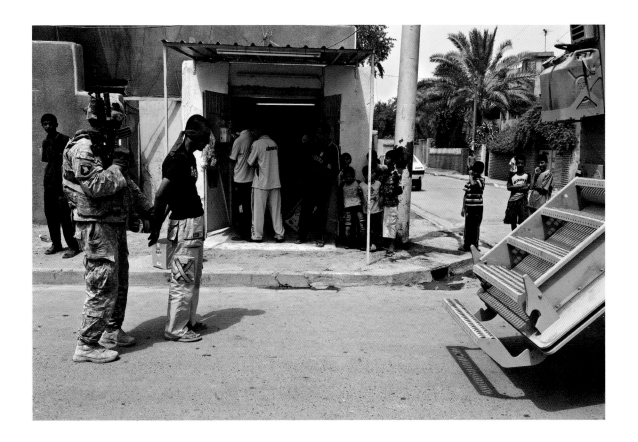

Within weeks of taking over the Mahdi Army offices, US forces
erect concrete and barbed wire barriers in Shula, 2008

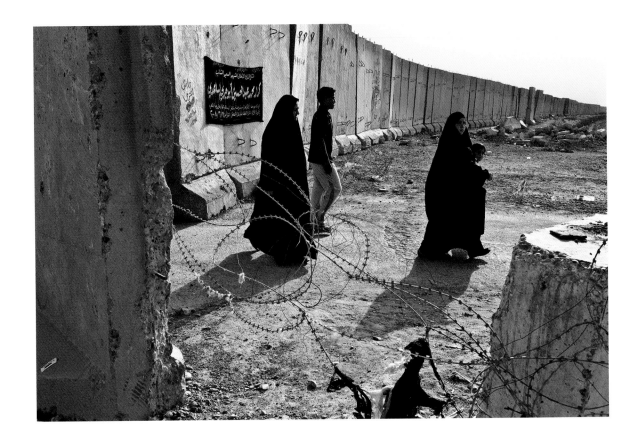

Because of the severe restriction on movement, food supplies
are running low. US and Iraqi soldiers distribute humanitarian
aid to residents. Shula, 2008

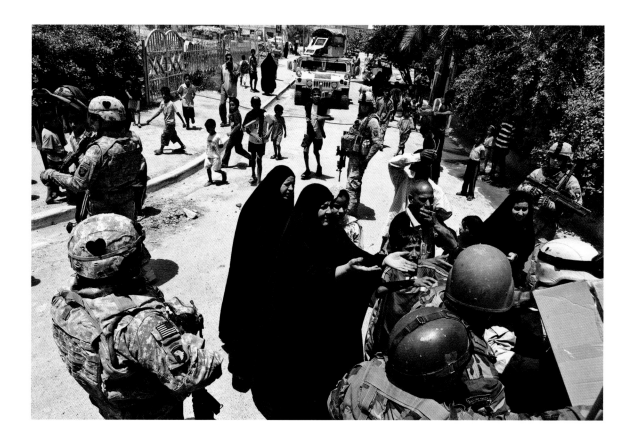

An exhausted US soldier in the Mahdi army offices
during the fighting, north west Baghdad, 2008

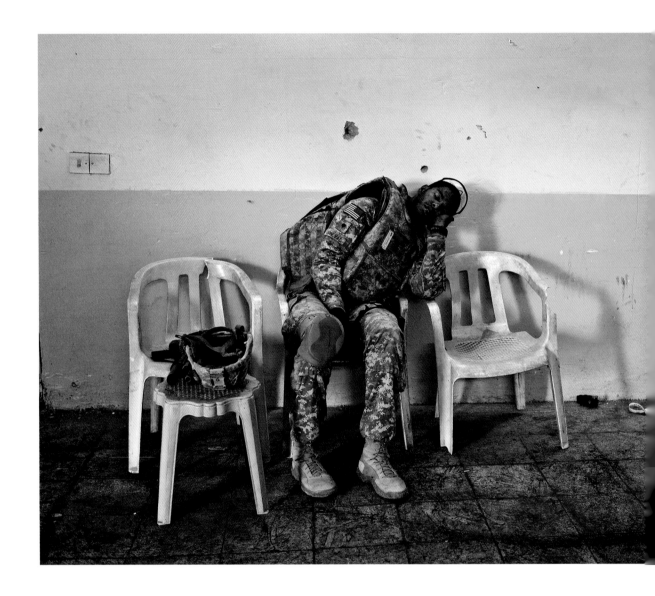

US soldiers from the 2nd Brigade Strykers Unit billeted in a disused
chicken coop in Maushadi near Tarmiya, north of Baghdad, 2008

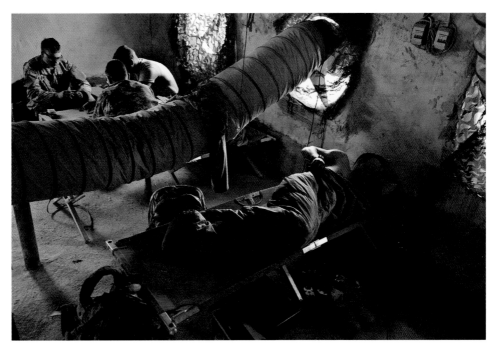

US and Iraqi soldiers uncover a large cache
of Mahdi army mortars, Shula, 2008

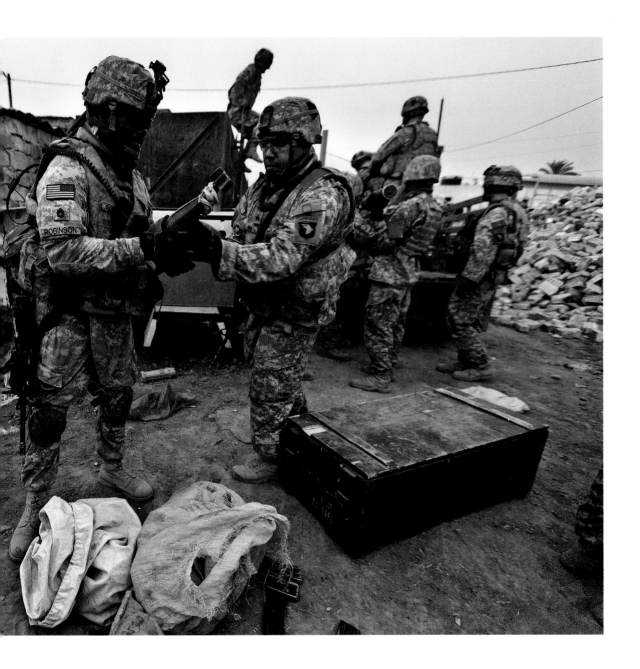

Mahdi army mortars and IEDs disguised as concrete blocks
and kerb stones being unearthed by 101st Airborne Division
together with the Iraqi army, north west Baghdad, 2008

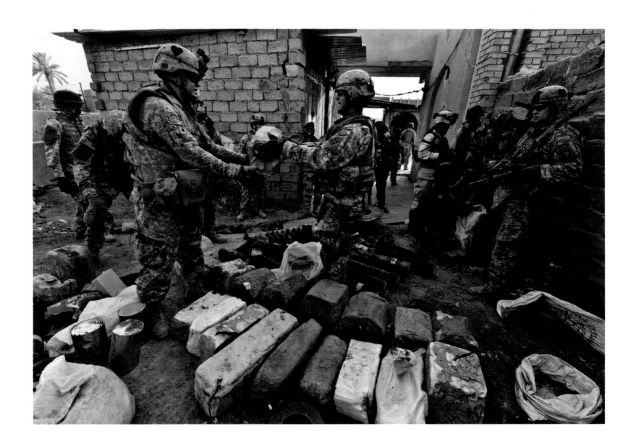

Two local civilians are detained in connection with the
discovery of the arms cache, north west Baghdad, 2008

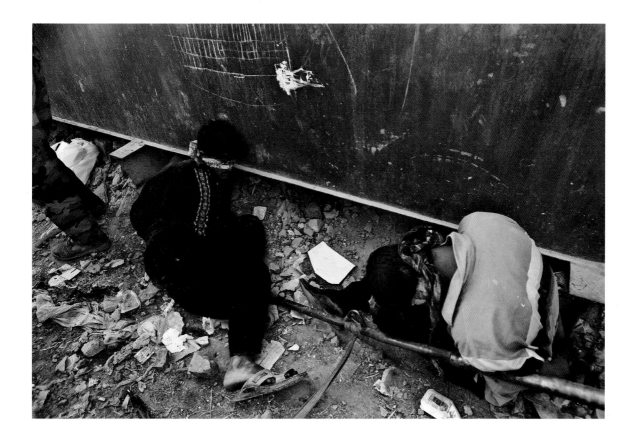

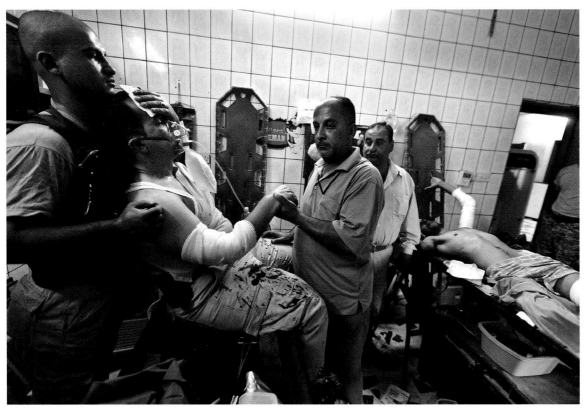

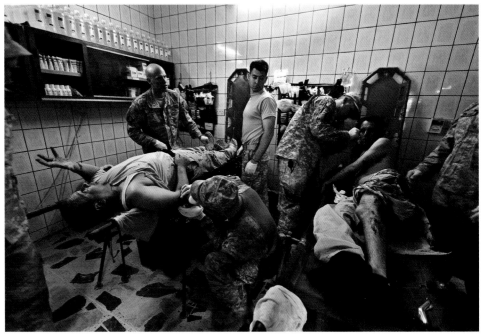

Members of 'The Sons of Iraq', one of the Sunni militia now cooperating with the US forces, injured by an IED roadside blast, being treated for their injuries at the joint security station at Ghazaliya, close to Shula, 2008

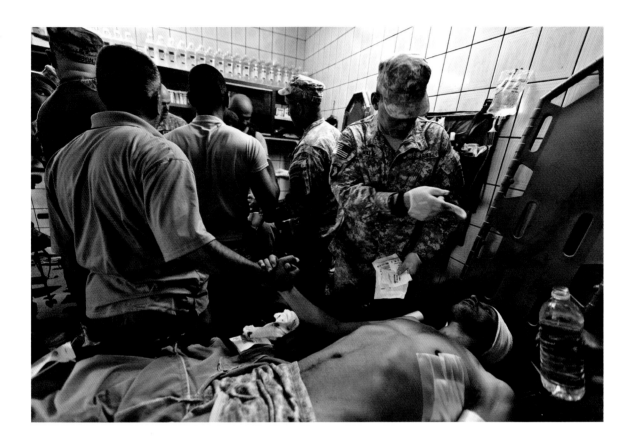

Sergeant John David Aragon (foreground) of 101st Airborne Division
asleep with comrades on the roof of the captured Mahdi army offices
during a break in the fighting, north west Baghdad, 2008

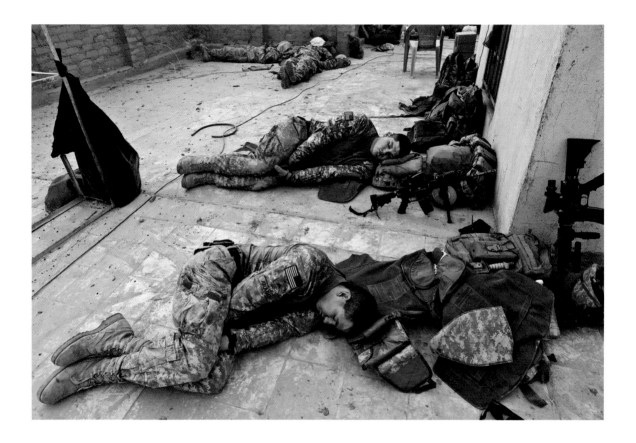

A man is stopped at gunpoint who is suspected of detonating an IED using a mobile phone. Smoke from the IED is visible in the background. Sergeant Aragon (previous picture) was killed in the attack and another injured. North west Baghdad, 2008

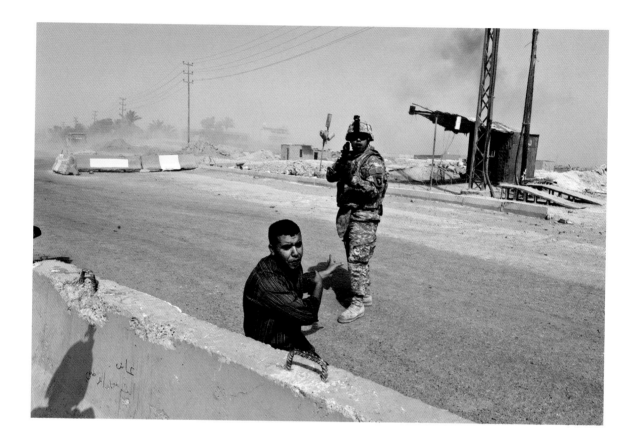

In response to Madhi army graffiti, a translator with 101st Airborne Division writes the following: '...whoever helps the coalition forces and Iraqi army by providing information re the terrorists and their weapons he will get a reward', north west Baghdad, 2008

AFGHANISTAN

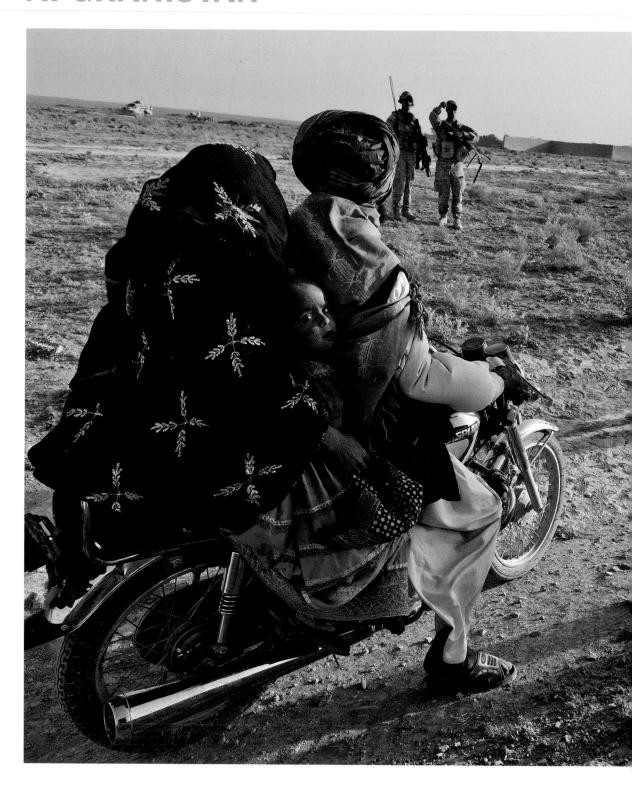

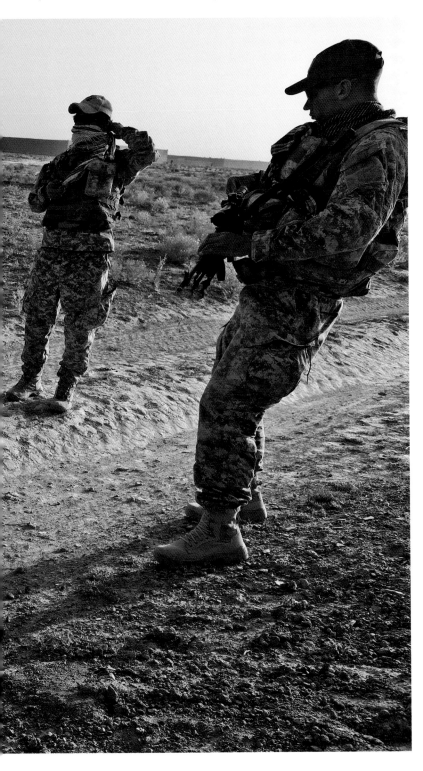

In the face of growing insurgency among Afghans and widespread disaffection with the occupation force, the newly elected US president, Barack Obama, announced plans to send an additional 17,000 troops to Afghanistan in February 2009. The following month, he called for the deployment of a further 4,000 US soldiers in order to accelerate the training of the Afghan army and police force. In July, US forces launched a major offensive in the south, centred on Helmand province, in advance of the upcoming presidential elections. Obama announced a further 'surge' of troops in December – an additional 30,000 soldiers, bringing the total to more than 100,000 – and named 2011 as the start of the American withdrawal.

501st Infantry (Airborne) stopping people after one of their vehicles had been hit by an IED en route to Jani Kheyl, West Paktika, 2009

Afghan police near Forward Operating
Base (FOB), Kushamond, 2009

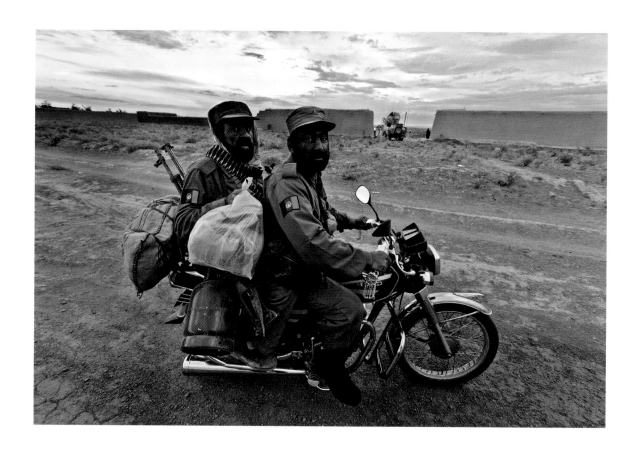

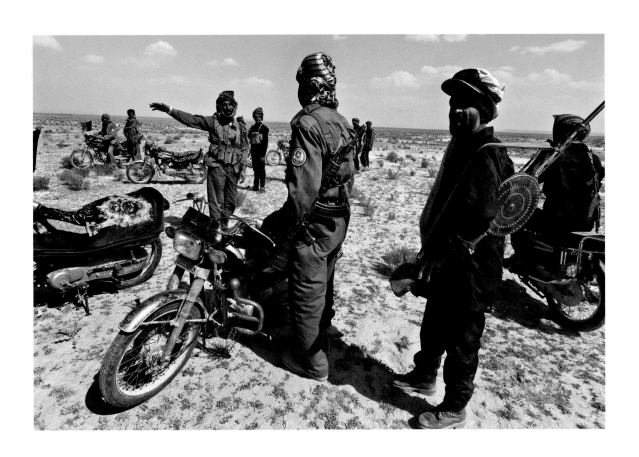

After US forces were shot at from Ashak village, all the local
men were rounded up to be photographed and fingerprinted,
Ashak, 2009

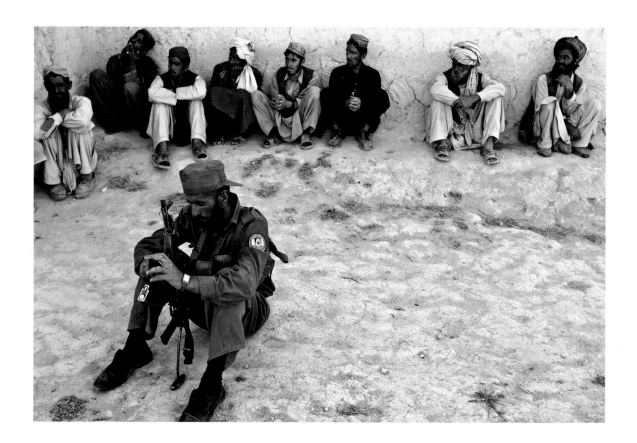

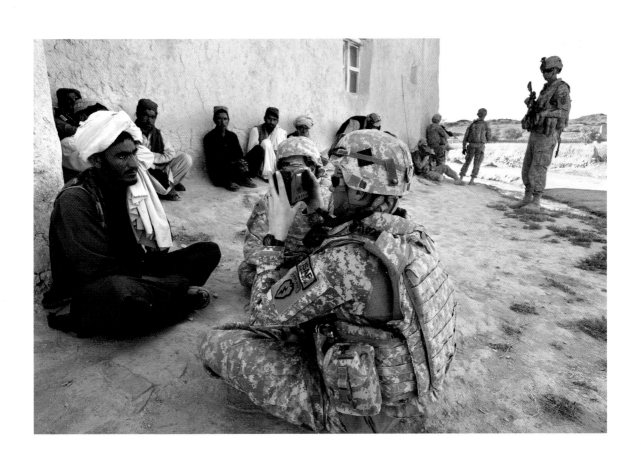

FRONTLINES | AFGHANISTAN

Soldiers from 501st Infantry (Airborne) inspect the damage to their Mine-Resistant
Ambush-Protected (MRAP) vehicle, on patrol from FOB Kushamond, 2009

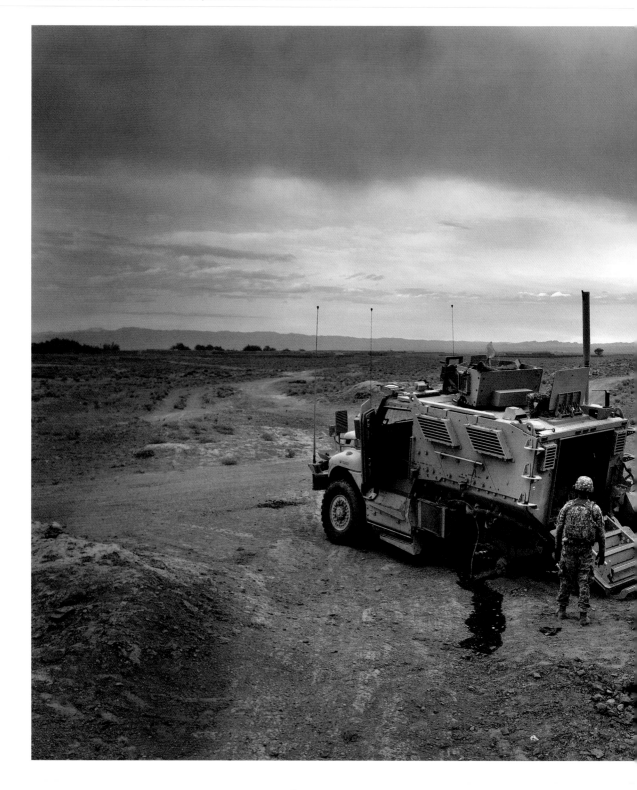

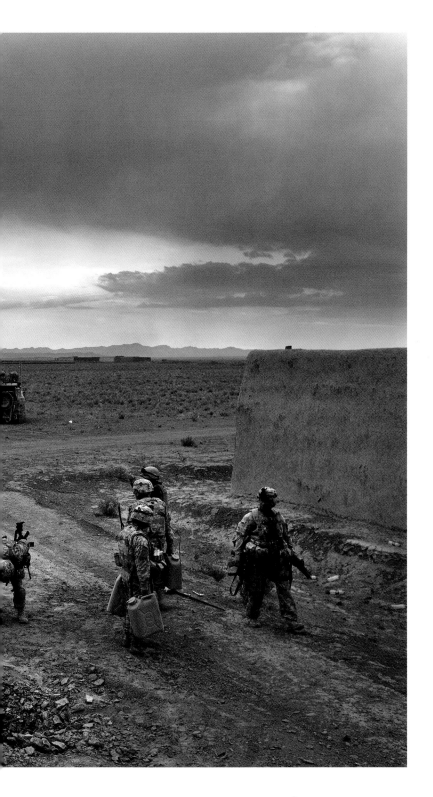

FRONTLINES | AFGHANISTAN

Afghan police questioning a local teenager in connection with the
IED attack on the MRAP, on patrol from FOB Kushamond, 2009

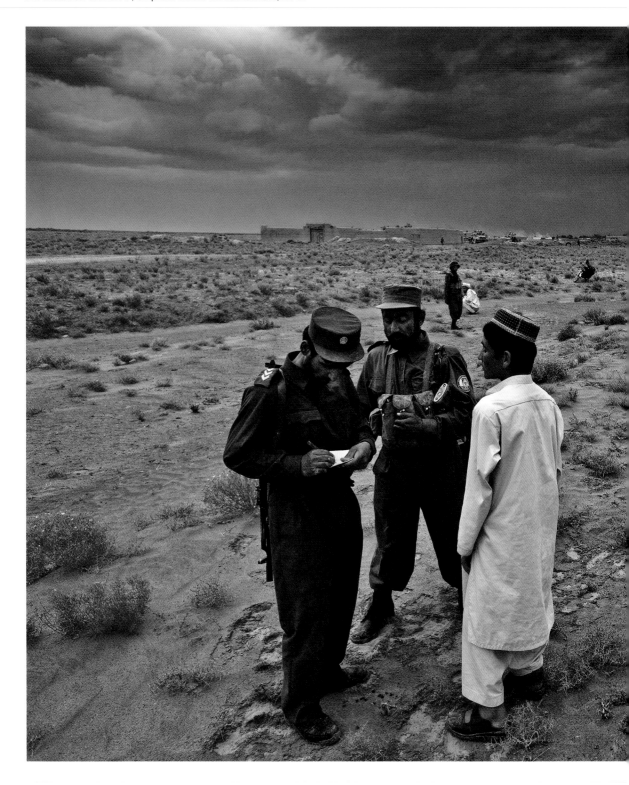

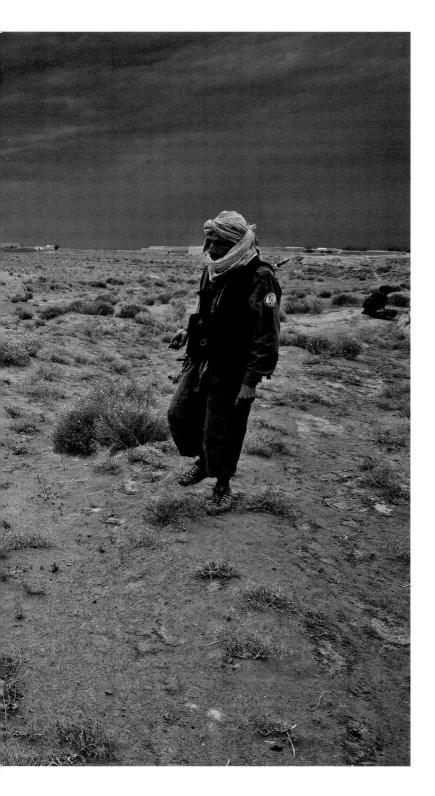

Specialist Bowe R Bergdahl (standing right) of 501st Infantry (Airborne) went missing a month after this photograph was taken. The Taliban has released four videos showing him in captivity. Temporary observations post to protect the construction of a new base for Afghan police and army, outskirts of Malakh, 2009

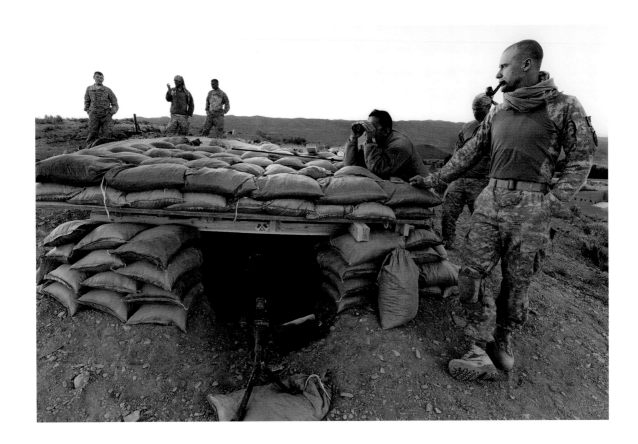

Specialist Bowe R Bergdahl (foreground) inside the
temporary observation post, outside Malakh, 2009

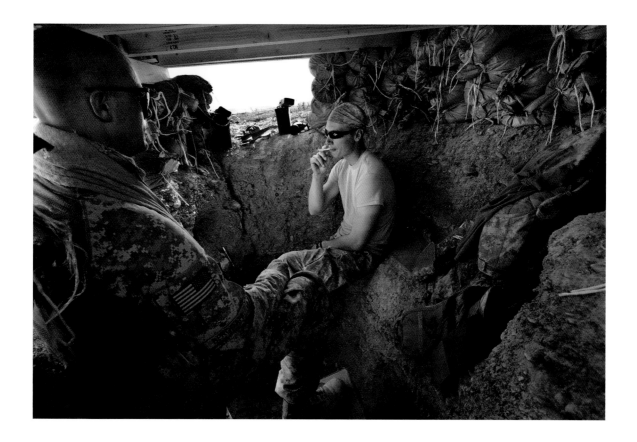

A British soldier from the Mercian Regiment mentoring
an Afghan soldier, Nawa, Helmand province, 2009

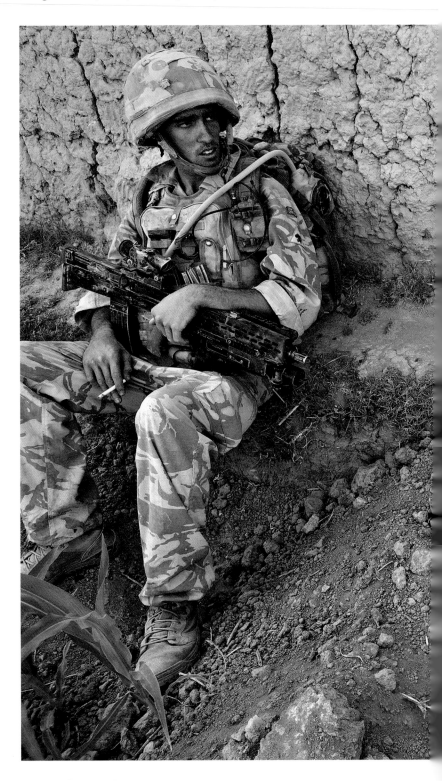

FRONTLINES | AFGHANISTAN

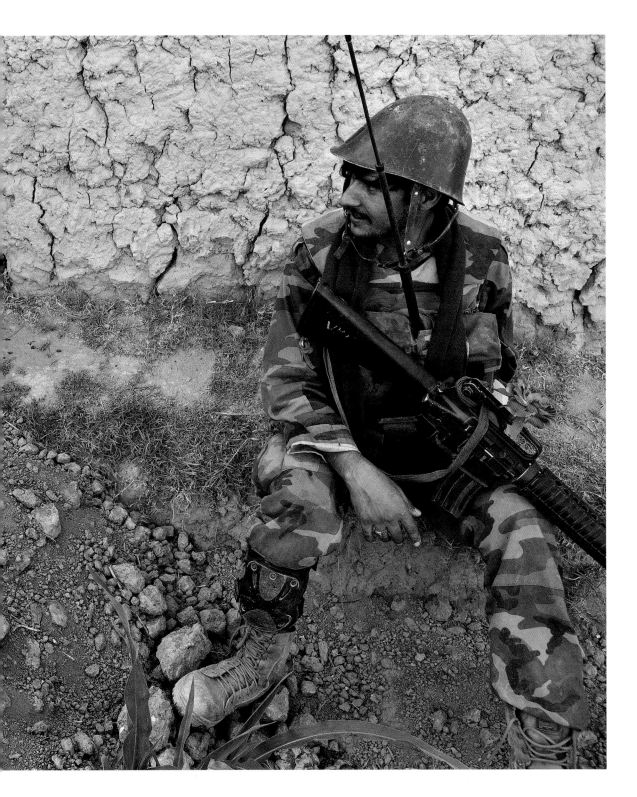

Soldiers from the Mercian Regiment mentoring team on patrol with the Afghan National Army. The area was in the process of being handed over to US Marines. Nawa, 2009

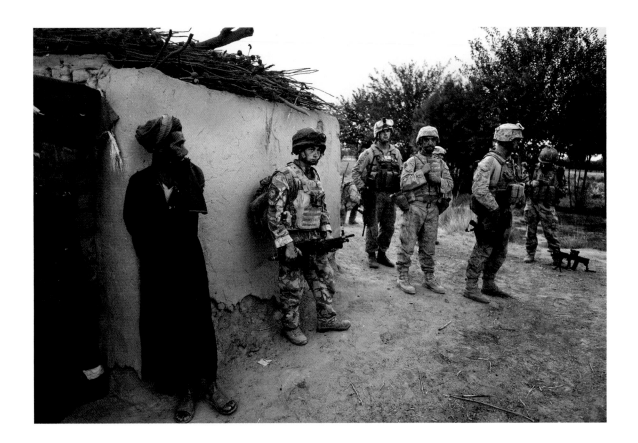

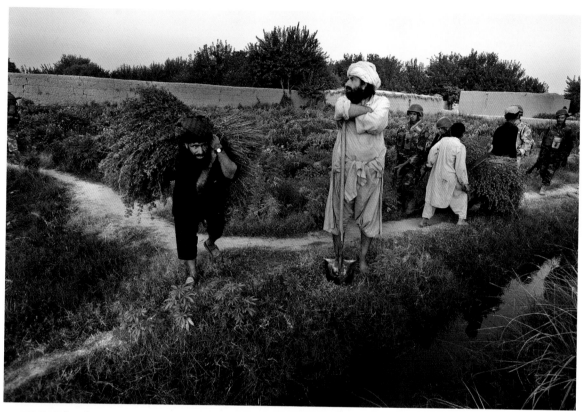

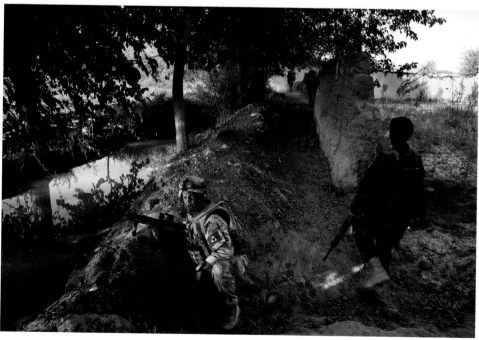

Soldiers from the Mercians relaxing, as
bemused locals look on, Nawa, 2009

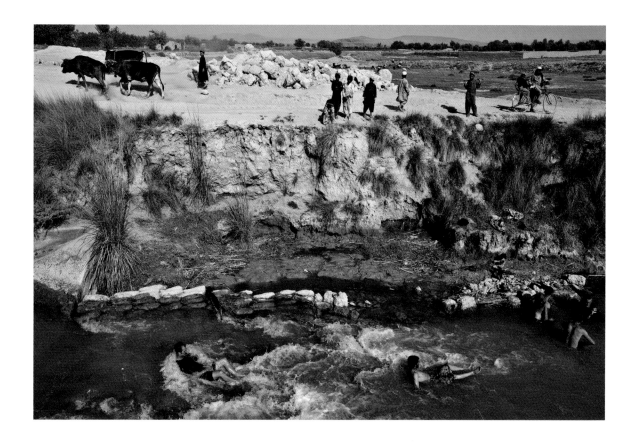

Joint patrol of Mercians, Afghan National
Army and US Marines, Nawa, 2009

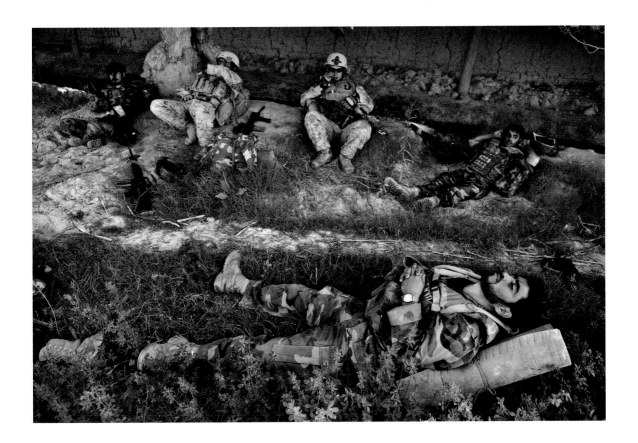

Soldiers from the Black Watch under attack create a smokescreen
to provide cover as they try to return to the base they are establishing
as part of Operation Panther's Claw, Babaji district, 2009

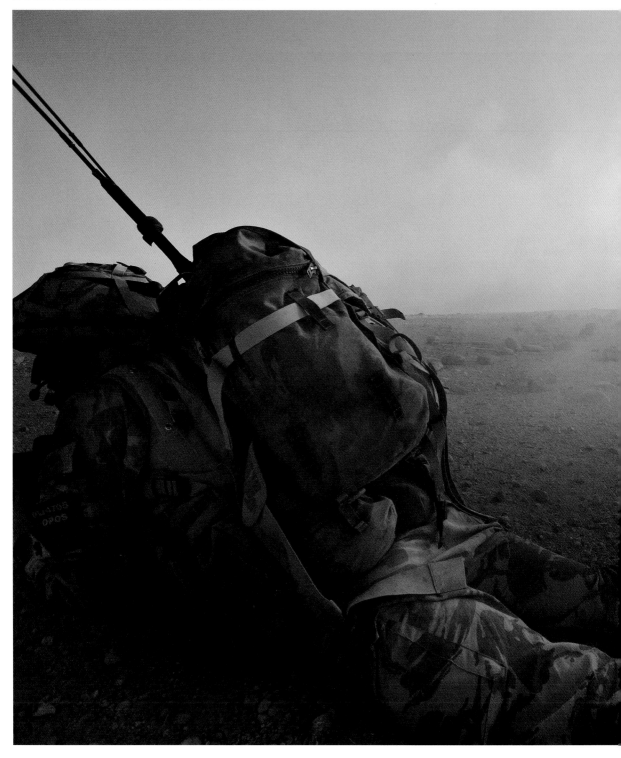

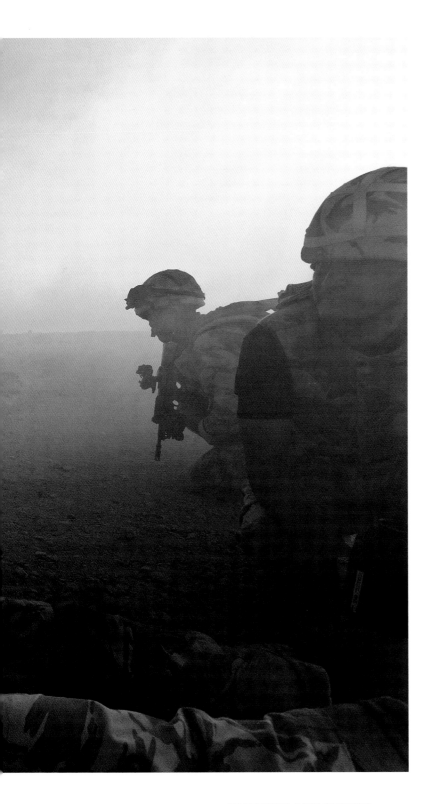

Soldiers from the Black Watch in the early stages of establishing
a base in an area controlled by the Taliban, Babaji district, 2009

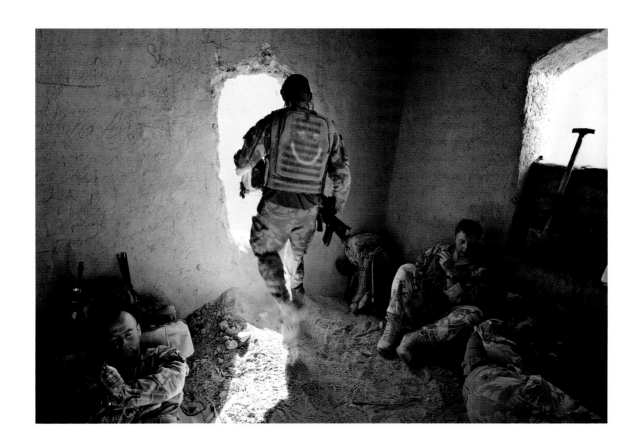

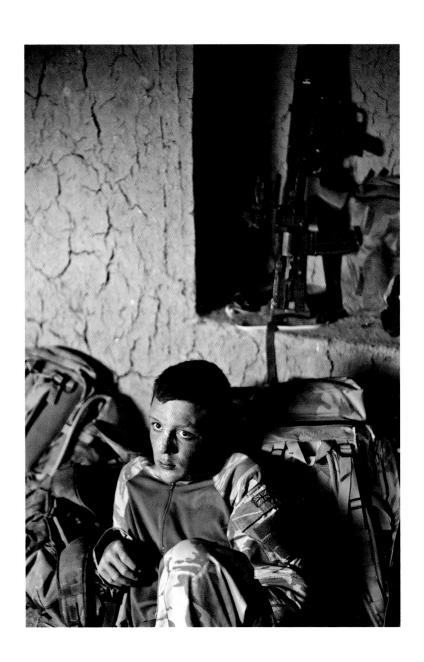

FRONTLINES | AFGHANISTAN

Soldiers from the Black Watch explode IEDs
around their new base in Babaji district, 2009

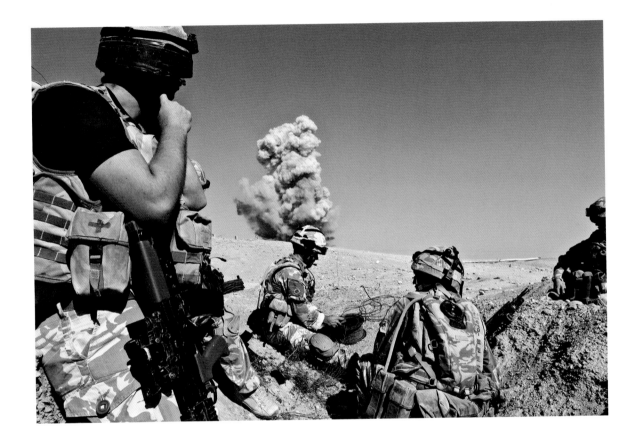

FRONTLINES | AFGHANISTAN

Black Watch soldiers return enemy fire,
Babaji district, 2009

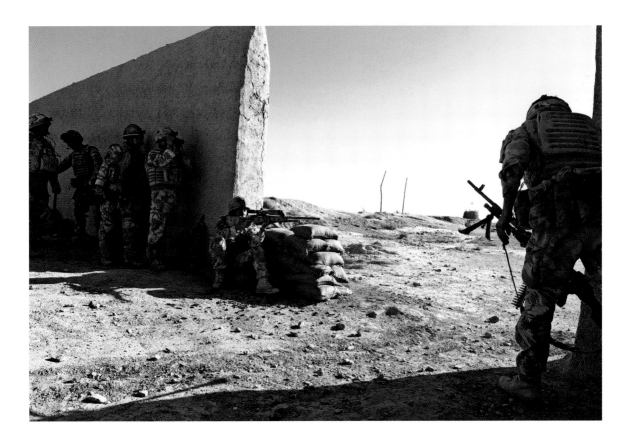

Black Watch soldiers returning fire,
Babaji district, 2009

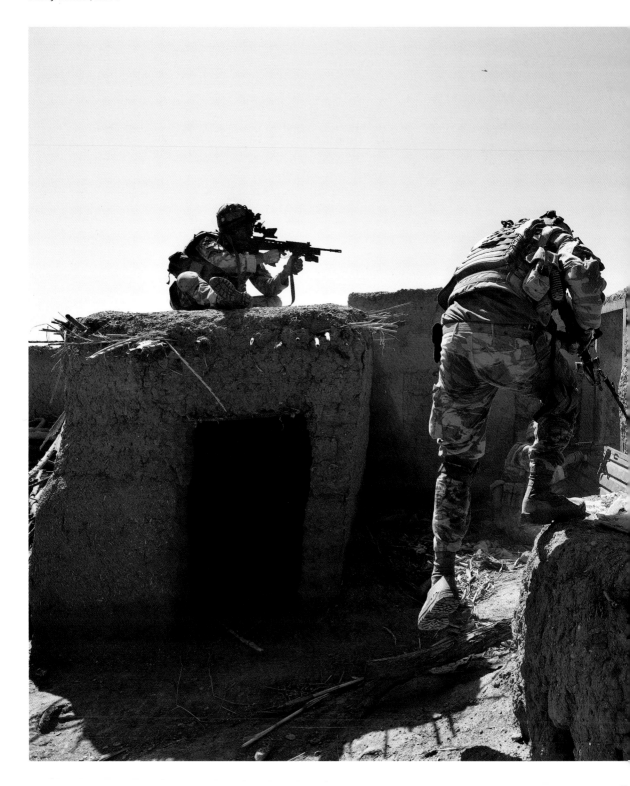

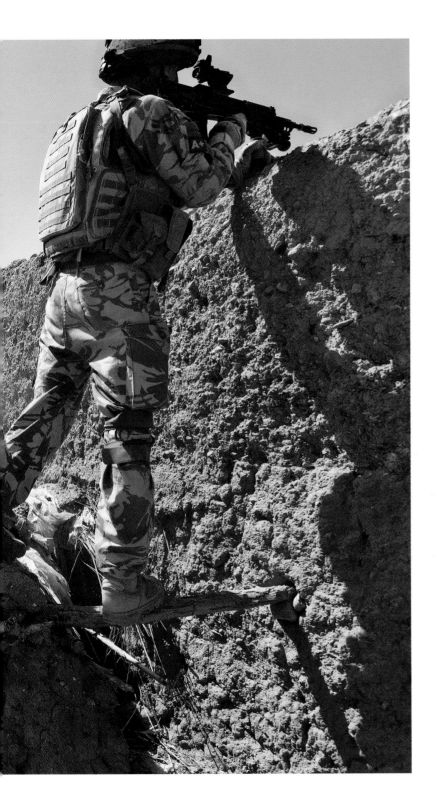

Black Watch soldiers on an early
morning patrol, Babaji district, 2009

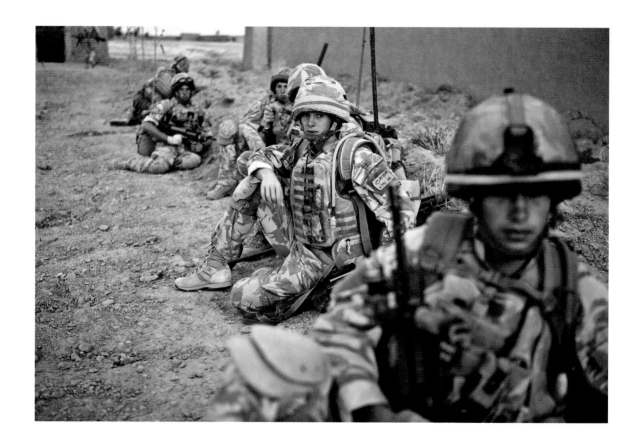

US Marines from Patrol Base Karma, in the wake of a firefight
with local insurgents, Gamsir, southern Helmand, 2010

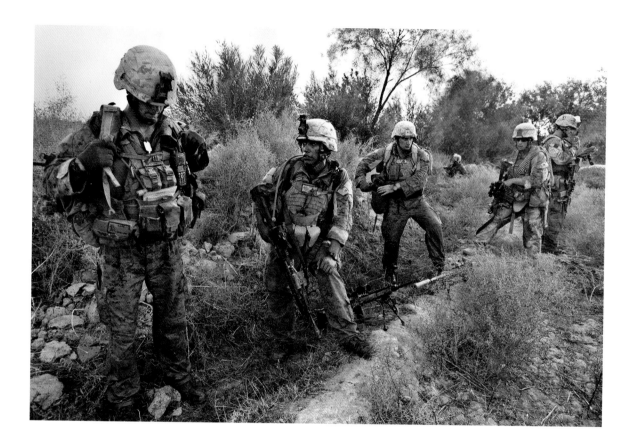

In the wake of an IED attack on one of their vehicles, soldiers from 501st Infantry (Airborne) take a break from talks with the village elders to allow them to pray, West Paktika, 2009

FRONTLINES | AFGHANISTAN

Pararescue Jumpers (US Air Force Special Operations
Command) retrieve a Canadian soldier injured by an IED,
Kandahar province, 2010

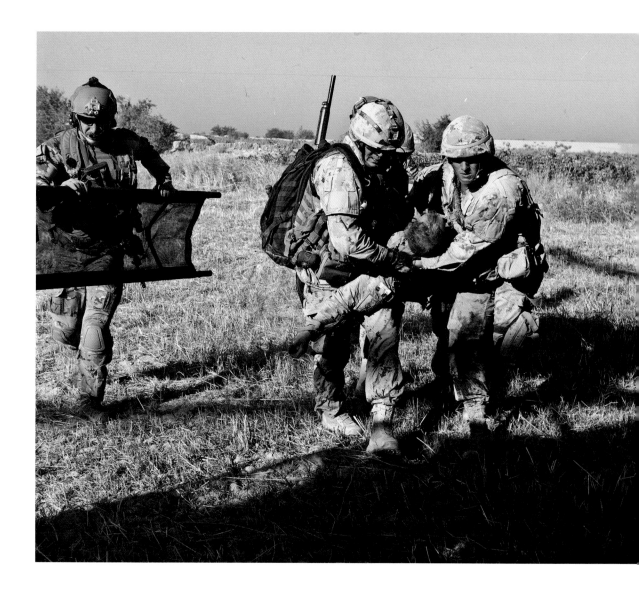

FRONTLINES | AFGHANISTAN

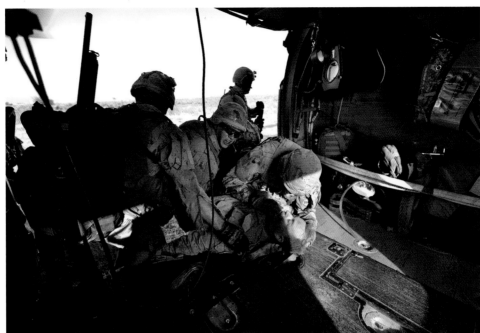

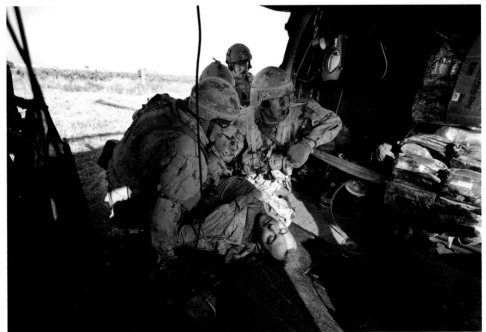

Pararescue Jumpers on a mission to retrieve injured,
Kandahar province, 2010

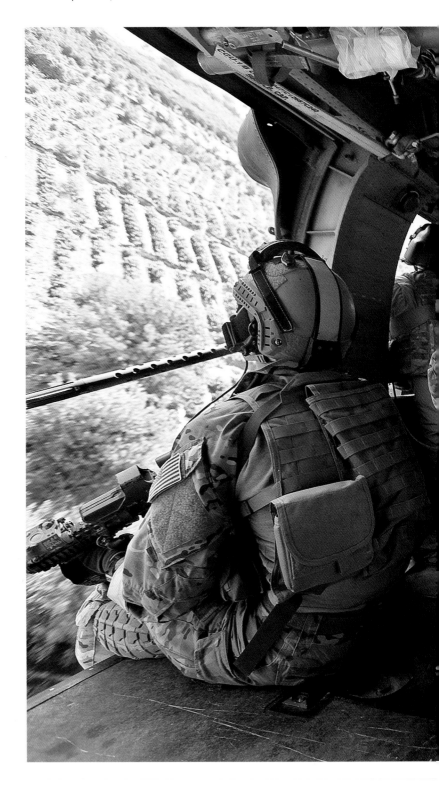

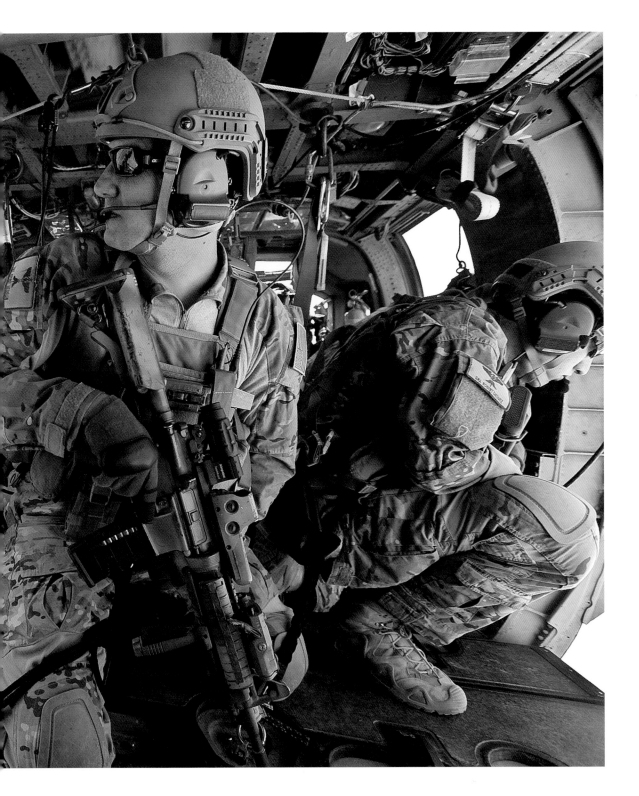

FRONTLINES | AFGHANISTAN

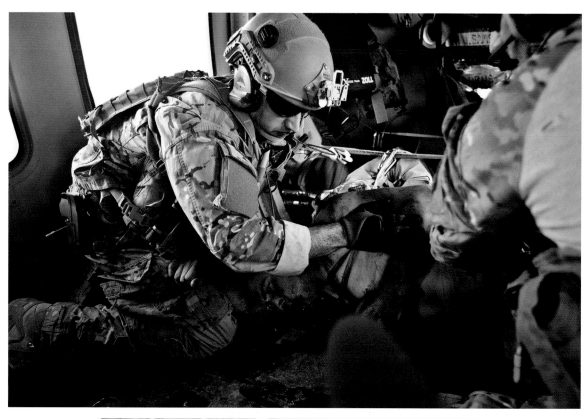

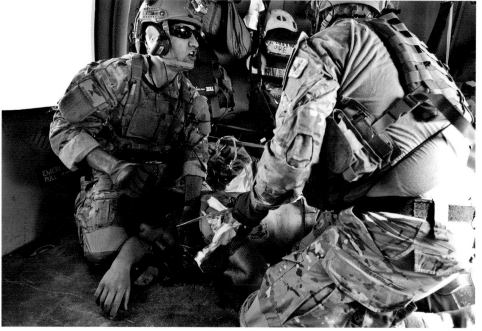

Pararescue Jumpers retrieve a US soldier who has been
shot while on patrol north of Kandahar city, 2010

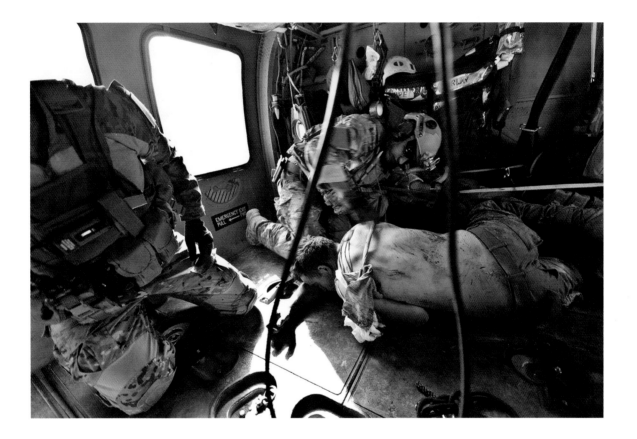

Early morning in Patrol Base Karma,
Gamsir, southern Helmand, 2010

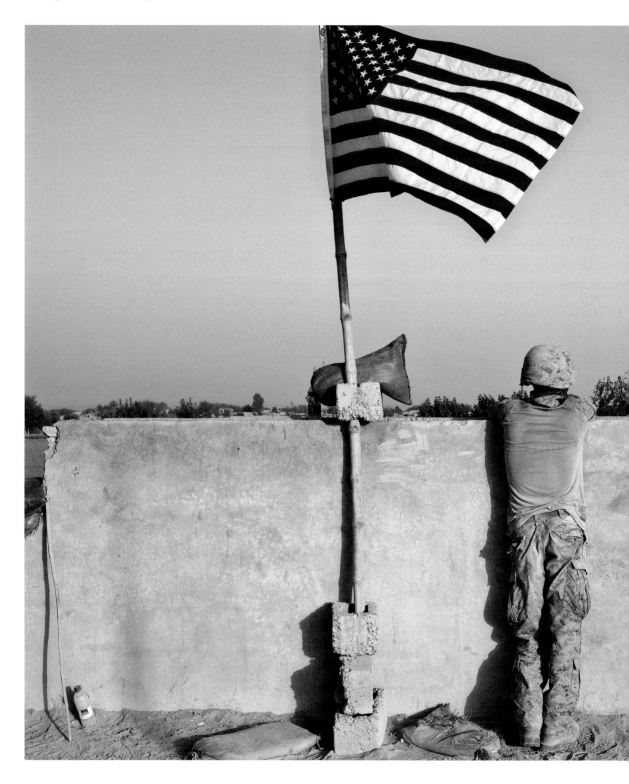

FRONTLINES | AFGHANISTAN

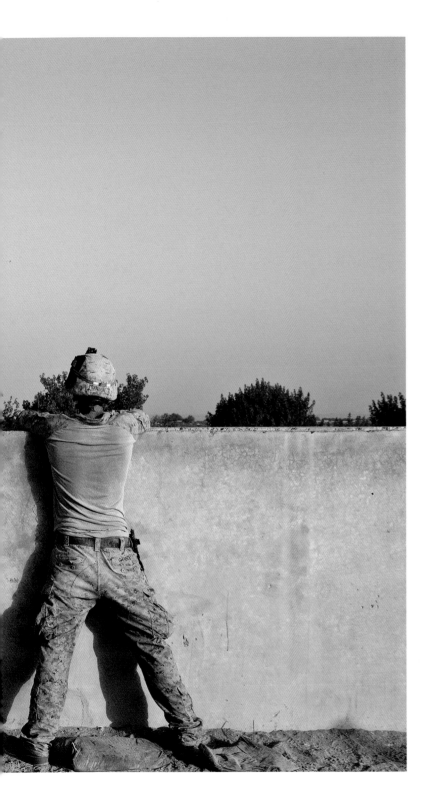

FRONTLINES | AFGHANISTAN